kandinsky

kandinsky

Arturo Bovi

Hamlyn

London New York Sydney Toronto

twentieth-century masters
General editors: H. L. Jaffé and A. Busignani
© copyright in the text G. C. Sansoni, Florence 1970
© copyright in the illustrations ADAGP, Paris 1970
© copyright this edition THE HAMLYN PUBLISHING GROUP LIMITED 1971
London · New York · Sydney · Toronto
Hamlyn House, Feltham, Middlesex, England
ISBN 0 600 35303 6

Printed in Italy by: Industria Grafica L'Impronta, Scandicci, Florence
Bound in Italy by: Poligrafici il Resto del Carlino, Bologna

Distributed in the United States of America by Crown Publishers Inc.

contents

List of colour plates

List of black-and-white illustrations

Matter and Spirit

Answering a questionnaire which he had drawn up himself, Kandinsky wrote: 'Painter, graphic artist and writer. He was the first to make painting a purely pictorial means of expression and to eliminate the objective elements of the image' *(Das Kunstblatt,* 1919, p. 172). But this is saying very little about him, and the manner is extraordinarily frigid and bureaucratic. When Kandinsky felt he had thoughts to express he wrote in a language reminiscent of Kafka's conversations with Janouch. His writing could be expansive and his manner messianic, particularly in some key passages with their important maxims; this however is not surprising since he found considerable limits in the way his peculiar talent was accepted.

On the problem of form he wrote:

'The new values which removed old barriers continually form new ones. This shows that basically the new value isn't important; what is important is the spirit revealed in it and the freedom required for it to reveal itself. Therefore the absolute should not be looked for in the form.

The form is always temporal and therefore relative because it is merely the contingent means, the means that are required for the revelation of the day, the means in which this revelation resounds.

Sound is therefore the spirit of form. Form can only become living through sound. Form operates from within towards the outside world.

Form is the outer expression of the inner content.

For this reason we should not make a divinity of form and we should fight for it only in as far as it can act as the expressive means to produce the inner resonance. Therefore one must not seek salvation in form.

This statement must be properly understood. For every artist (who is a productive and not a receptive artist), his own expressive means (=form) is the best in as far as it embodies in the best way possible the message which he is pledged to communicate. Therefore the deduction that this expressive means is or should be the best for other artists too is mistaken.

As form alone is an expression of content and as content is various in the work of various artists, there can obviously exist various equally good forms at the same time.

Necessity creates form. Fishes living in very deep waters have no eyes. The elephant has a proboscis. The chameleon changes colour, and so on.

Thus the spirit of the individual artist is reflected in a form.

Form renders the mark of personality.

Nevertheless personality cannot of course be conceived as an entity beyond time and space. On the contrary, it is to some extent subordinate to time (period) and to space (people).

Every artist has his message to communicate; this is also true of every

people and therefore also of the people he belongs to. This bond is reflected in the form and is shown in the national features of the work of art.

In fact, every period also has its specific task; to reveal what can only be revealed by its own means. The reflection of this historical factor is shown in the work of art as style.

These three elements which together constitute the characteristic mark of a work cannot be eliminated. It is not only superfluous, but even harmful to worry oneself about the fact that they are there; in fact even here violence can only produce an illusion, a temporary deceit.

On the other hand it is obviously superfluous and harmful to give special pre-eminence to one of the three elements. Many people take care to emphasize the national element; others concentrate on style; not long ago people indulged in a cult of the personality (the individual element).

As was stated at the beginning, the abstract spirit begins by taking possession of an individual human spirit and then dominates a continuously increasing number of people. Then the individual artists succumb to the spirit of the time, which compels them to use related forms which have a similar appearance.

This moment of time is defined as a movement.

A movement is perfectly legitimate (just like the individual form for the artist) and it is indispensable for every group of artists. And just as salvation must not be sought in the form of an individual artist, so it must not be sought in the form of a group. For every group, its own form is the best in as far as it embodies the message which the group itself is pledged to communicate. But it would be wrong to deduce that this form is or should be the best for all groups. Here too there should be complete freedom and the work should be acknowledged as valid; every form which is the outer expression of an inner content should be considered correct (= artistic).

When the process is different, the group no longer serves the free spirit (the white ray) but the petrified barrier (black hand).

Therefore here too we reach the same conclusion as before: the important thing is not usually form (Matter), but content (Spirit)'.

(*Il Cavaliere Azzurro*, De Donato, Bari, 1967, pp. 127–130).

This is the key passage, Kandinsky's messianic statement: Matter-Spirit with its capital letters with their mystical and symbolical origin (which will be discussed later). It implies a universal animism and a love of life which is significant in assessing the value of the artist's personality. For 'the poetic theory does not create art, but the artist creates poetic theory'. Kandinsky is well aware of this in his love of theorizing. We have already noted this in the quotation referring to the problem of form. The problem will now be taken up again in the formulation which the artist gave it initially (op. cit. pp. 122–126). The core of his thought is contained in the following important passage: 'At a determined moment, necessities mature. That is, the creative Spirit (which we may call the abstract Spirit) succeeds in opening a passage first into one soul, then into the others, arousing nostalgia, an inner impulse. When the conditions required for maturing a precise form have materialized, the inner impulse becomes so strong that it creates a new value in the human Spirit, a value which begins to live in the consciousness or the subconscious of man. From that moment, knowingly or unknowingly, man begins to seek a material form for the new value existing within him in a spiritual form.' Here Kandinsky points to 'the search for the Positive, the Creative, the Good; the white ray that fertilizes. The white ray determines evolution, elevation. Behind Matter, within Matter, the creative Spirit is concealed. The material veils that enclose the Spirit are often so thick that men capable of perceiving it clearly are usually few. There are in fact many men who are unable to see the Spirit in its spiritual form. This is why even today many men see the Spirit in religion and not in art. There are whole periods which deny the Spirit because the eyes of men generally are not able to see it.' Clearly one can still see the germs of certain important theosophical ideas in Kandinsky's thought: first, Larianov's

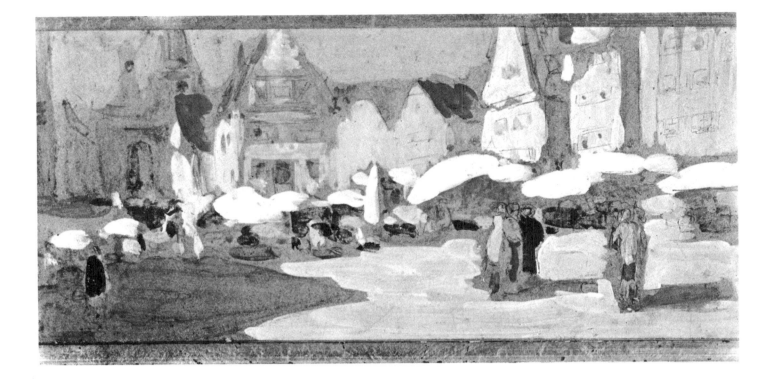

theories in his *Manifesto of the Ray Theory* (1911); Larianov sings hymns of praise to the East and opposes individualism and the West; secondly, the ideas of Theodore Lipps who propounded the theory of empathy *(Einfühlung)* at the University of Munich, referring to the evocative significance of line and preparing experiments on the effects of linear movements in the human psyche. Moreover Wilhelm Worringer published an essay *Abstraktion und Einfühlung* in Munich in 1908 which is of capital importance for the understanding of Kandinsky's essay *Concerning the Spiritual in Art (Uber das Geistige in der Kunst, Insbesondere in der Malerei,* Piper, Munich, 1912).

In *Der Blaue Reiter* (first and second German editions, Piper, Munich, 1912 and 1914) Kandinsky wrote: 'In the nineteenth century and even today men remain blinded. A black hand rests on their eyes. It is the hand of hatred. Whoever hates tries in every way to curb evolution and elevation, and this is negativity, the destructive principle; it is Evil; the black hand that kills.' Here he explains why art must develop in a direction that opposes this situation; and, as his thought develops (as we mentioned previously), he shows the *sine qua non* for a new language, the 'inner condition' for form, the first starting-point from which a new kind of language can develop in the way of a 'positive reality'.

This is certainly true within the sphere of freedom; but the role of intelligence is less clear; this is the difficulty. Before we discuss the particular problems that are clearly put in the *Blaue Reiter* and Kandinsky's later works, we must emphasize that he is attempting to break out of the closed sphere of private controversies, since these cannot resolve the cardinal questions of art and aesthetics. His aim is to break out of the early period of his artistic activities and the development of his thought, and to deal with a problem which vitally concerns man and the artist, the source and progress of his existence, the new assessment of time (period) and space (people), with which his reality, his consciousness and his inner impulses have strong links and affinities. When we read the essays of Paul Klee written when he was teaching at the Bauhaus, one realizes how well he understood Kandinsky's remarkable intelligence and acutely critical and creative powers of observation. The conclusions of both men at certain stages of their thinking and their artistic work differ in some fundamental respects, but they share the same penetrating intelligence. They reveal and define the new concept of the 'inner impulse'; they show the need for a 'scientific and ethically active

1 *Market place*
1901, oil on board
6 × 13 in (15 × 33 cm)
Musée d'Art Moderne, Paris

9

analysis', and the awareness of the artist which must transcend purely sensuous perceptions.

Unknown greatness

In his creative confessions *(Nell' Interregno,* Edizioni Mediterranee, Rome, 1958) Paul Klee wrote: 'I–Art does not reproduce what is visible, but it makes visible what is sometimes invisible. The essence of drawing may lead easily and rightly to abstraction. The schematic and fabulous element in an imaginary feature are rendered and at the same time expressed with great precision. Graphic art is purer: the greater the weight given to the formal elements of graphic reproduction, the more inadequate is the structure of the realistic reproduction of visible objects. The formal elements of graphic art are the points, the linear energies of surface and space. A determined surface which does not consist of secondary elements is, for instance, an energy executed with a pencil with a thick point, with or without modulation. A spatial energy may be, for instance, a dark, cloud-shaped mark, executed with a full paint-brush in various gradations.'

In paragraph IV Klee wrote: 'Movement is the basis of all growth. In Lessing's *Laocoon,* which stimulated many of my thoughts as a young man, there is much discussion of the difference between art in time and in space. However, when I examined the book more closely I noted that it was merely the idle talk of a scholar, because space too is a concept of time. Time is required before a point becomes movement and line, and also before a line is converted to a surface. The same applies before surfaces are transmuted into spaces. Does a painting appear all at once? No, it is constructed piece by piece, just like a house. And does the spectator finish with it all at once? Unfortunately he frequently does. Yet Feuerbach said that a chair is required to understand a work of art. Why a chair? So that tired legs do not disturb the mind. Legs become tired if one keeps standing too long. For this reason the field of art requires time, and the artistic movement requires movement.'

In paragraph V, Klee wrote: 'Formerly people painted what was visible around us, what could be seen with pleasure. Today the reality of visible objects is revealed; we have proof of the belief that visible objects are only an isolated example in the universe and that the greater part of the universe consists of other latent truths. Objects appear in an extended and varied aspect, often contrasting with the rational experience of yesterday. There is a tendency to stress the essential element of the accidental.'

Klee also wrote in paragraph VII: 'Art reflects what is created. It is always an example, just as earthly things are a cosmic example. The scission of the elements, their regrouping in sub-species, the separation and reunification of several parts in their integrity simultaneously, figurative polyphony, the creation of a state of rest by means of the balance of movements, all this represents an important problem of form, essential for formal wisdom, but it is not yet art in its more advanced stage. In its most advanced stage, behind the veil of the hermetic art, there is an intimate secret before which the light of the intellect fades out miserably.'

In 1928 Klee in his essay 'Precise Experiences in the Field of Art', published in the *Bauhaus Review,* made a statement similar to Kandinsky's on the necessity for a scientific analysis in which the 'unknown greatness' may be always more closely perceived in the 'essence of art'. 'Even in art there is plenty of opportunity for exact research and much research has been and is being undertaken. What has been done in music since the beginning of the eighteenth century (Klee studied Bach and Mozart) is at least at its beginning in the figurative arts. Mathematics and physics supply the necessary tool, i.e. the rule, to verify abnormality and anomaly. It is wise to concern oneself here primarily with functions rather than completed form. Problems of algebra, geometry and mechanics merely represent didactic moments along the path leading to the essential: function as opposed to impression: one learns to see behind the façade, to grasp things at the roots; one learns to ascertain what flows below; one apprehends the pre-

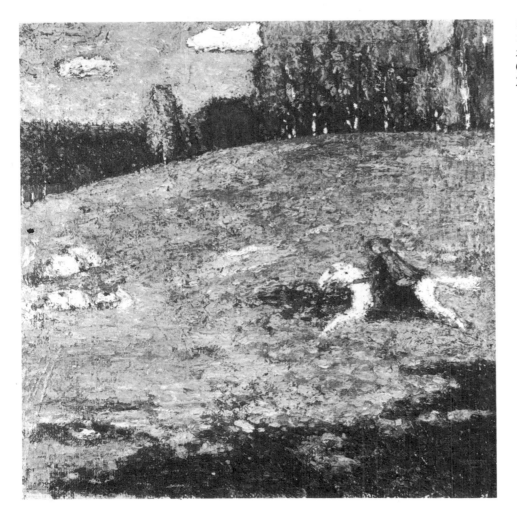

2 *The blue rider*
1903, oil on canvas
$20\frac{1}{2} \times 21\frac{1}{2}$ in (52 × 54·5 cm)
Collection Ernst Bührle,
Zürich

history of the visible, one learns to dig in depth, to lay bare, one learns to state reasons, one learns to analyze.'

If one considers the development of Kandinsky's thought in *Value of Theoretical Teaching in Painting* (which reaffirms some fundamental concepts already stated in *Concerning the Spiritual in Art*) and in *Point and Line to Plane* (*Punkt und Linie zu Fläche: Beitrag zur Analyse der malerischen Elemente*), both published for the Bauhaus in Munich in 1926, one can perceive a line of thought, beginning with the magic idealism of that romantic thinker Novalis and progressing through the logical rigour of Husserl's philosophy, in which Kandinsky's original romantic impulse is not lost.

In *Value of Theoretical Teaching in Painting*, Kandinsky wrote: 'The analytical path is a premise in all spheres because the unilateral affirmation of intuition has brought many disadvantages. Feeling close to the elements of painting and its laws helps one to understand the elements and laws of the other arts and of nature; it facilitates the synthesis of all that is spiritually artistic; it helps to overcome specialization (professional skills) and leads to true education.' This is still one of the fundamental premises for the development of the new language, and it is brought within the field of research in *Point and Line to Plane*: the analysis of the expressive values of the point and line in relation to space, forms and colours is developed in the infinite possibilities of their inter-relationship and in relation to the structure of perception.

Kandinsky considered that 'natural forms are in reality small bodies in space and their relation with the geometrical abstract point is the same as with the pictorial point. However the whole world may on the other hand be considered as a cosmic composition contained in itself which in its own turn consists of an infinite number of independent compositions always contained in themselves and becoming smaller and smaller. In the last analysis all have originated as points, and it is to the point in its geometrical

Point and line to plane

11

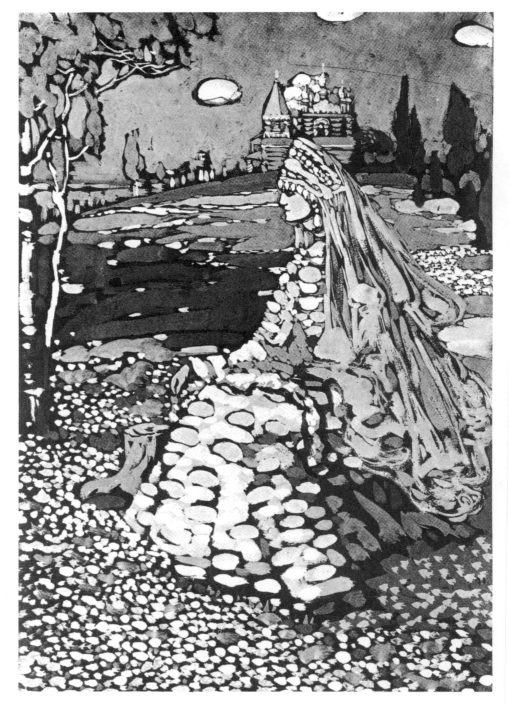

Russian beauty in a landscape
1905, tempera on board
$16\frac{1}{2} \times 11\frac{1}{2}$ in (42×29 cm)
Städtische Galerie,
Munich

essence that everything returns. These compositions are complexes of geometrical points suspended in geometrical infinity in various regular figures. The smallest self-enclosed forms are completely centrifugal figures and appear to the naked eye as points that have an apparent inter-relation. Many seeds appear like this to us. When we open the beautiful, highly polished ivory-white capsule containing the seeds of the poppy (in fact it resembles a large spherical point), we discover masses of cold grey-blue points, regulated by the laws of physics to form an orderly composition, containing a latent silent generating power just like a pictorial point. Often in nature these forms take life by separating and disjoining themselves from the above-mentioned complexes: they are making an advance on the primordial form of geometrical space. If the desert is a sea of sand consisting entirely of points, the capacity for invincible and violent movement which these points have to move from one plane to another is terrifying. Thus in nature too the point is well-contained and full of possibilities' *(Point and Line to Plane,* pp. 36–37).

The search for truth When we examine the various stages in Kandinsky's work, we shall see how he came to paint his first abstract (a water-colour) in 1910; he had contact Fig. 10

12

4 *Country church*
1908, oil on board
13 × 17¾ in (33 × 45 cm)
Von der Heidt Museum,
Wuppertal

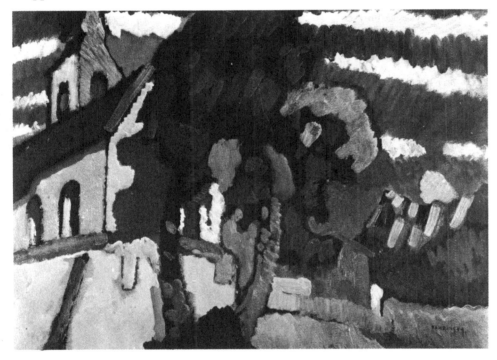

with an artistic circle which influenced him directly and indirectly in his work and his theoretical writings, and he was familiar with paintings which determined the development of his own artistic language. But all this cannot explain the fundamental reasons for the way his personality reached, as he himself said, the 'inner awareness' the 'inner condition' for his activities, and then the requirement for a new form. For this reason he sees artists as philosophers looking for truth. He felt that the universe must be interpreted according to the laws of the inner vision and of a space from which images appear with a symbolical significance. In the 1890's when he was in Paris and his paintings were still representational, he was influenced by the cloisonnism of the Pont Aven artists and the chromo-luminarism of Seurat; and, in the beginning of the century in Munich, by the Symbolist poets and the Jugendstil as well as the theories of Lipps and Worringer which we have already mentioned.

I admit that although the Jugendstil, the Symbolist poets and popular Russian art are important in Kandinsky's experience and, particularly in the case of German Expressionism, in the main field of his graphic art, the crisis and its sequel which affected the Impressionists was far more decisive even than his experiences with the form and colour of Fauvism. There was

a crisis in the values, intellectual content and manner of Bastien-Lepage, Besnard and Boldini; 'modern art' appeared (beside the art of Cézanne, of analytical and synthetic Cubism and Russian Constructivism) in the rigorously scientific formulation which Seurat made of the light and colour of Impressionism; this was similar to the ideas of Fénéon and Sutter who investigated the optical researches of Chevreul. At the same time Monet and Pissarro carried out research on the visual aspects of the emotions. The important point to make is that 'whilst it is true that sensation and perception are in no way eternal but change continuously, it is equally true that consciousness, appearing in whatever phenomenon it assumes, reveals a constant structure and attitude. Indeed, Monet, who developed the premises of Impressionism with complete coherence, perceived more clearly every day that sensation is not only a visual fact but engages all existence and touches the deepest strata of feeling' (G.C. Argan, *Salvezza e caduta nell'arte moderna*, Il Saggiatore, Milan, 1964, p. 19).

Everything is in the mind

Proust's statement that only a gross and mistaken perception places everything in the object, since in fact everything is in the mind, is crucial for the understanding not only of Proust, but of Kandinsky and of the future. We must therefore consider how this concept coincides with the main premises in Kandinsky's critical and creative ideas already mentioned. The development of Proust and Kandinsky is particularly interesting because the time they lived in divides and separates into two currents of thought: Bergson's and Husserl's. To understand their important differences, we must consider the problem of science which covers mainly the same area of thought.

Bergson's starting point is the analysis of awareness as an inner experience grasped in its immediacy. Proust makes a new evaluation of the consistency of time, in the origin and 'real duration' of time, in the involuntary and voluntary process of memory coinciding in a dimension of awareness. 'For a conscious being', wrote Bergson in *Evolution créatrice*, 'to exist means to change, to change means to mature, to mature means to create oneself indefinitely.' The process of awareness is a continuous creation; it is invention, progress and freedom which cannot ever be forecast or ever be causally determined. Creative evolution is designed to show how the very world of action and perception as a system of exteriorized and spatialized images and therefore as the object of intelligence and science is constituted by that same movement which is the temporal process of conscious life. Bergson relates biological life to the life of consciousness, to real duration. 'Instinct and intelligence are different tendencies, but connected and never completely separable.' There are things, Bergson said, which only intelligence is capable of looking for, but which it will never find on its own. 'The instinct alone could find these things; but it will never look for them.' This is a situation which shows an aspect of Proust's *Remembrance of Things Past* in its essence, in the contrasts of its development which is life itself; but life, in the very act in which it is denied (perhaps unconsciously indeed) may also be the negative product of the greatest of its contradictions: 'Our social personality is a creation of others' thought' *(A la recherche du temps perdu, Du côté de chez Swann, passim)*.

Function opposed to impression

Beyond time, as 'duration of time' in its development, which is the very life of man, science substitutes according to Bergson a homogeneous and uniform time which in fact is no longer time, but space. It may appear obvious that Kandinsky wanted to reach this dimension with the aid of science; but the inner need of his spirit appeared first as emotion and memory, later he became ready to embrace the world of the unconscious. He anticipated the analytical methods of a remarkable development in modern art, following a similar line to that of Klee (see his *Precise Experiences in the Field of Art)* with the important conclusion: 'function opposed to impression'. Lévi-Strauss's definition of the concept of structure, according to which all structures can be brought back to mental structures because they are merely

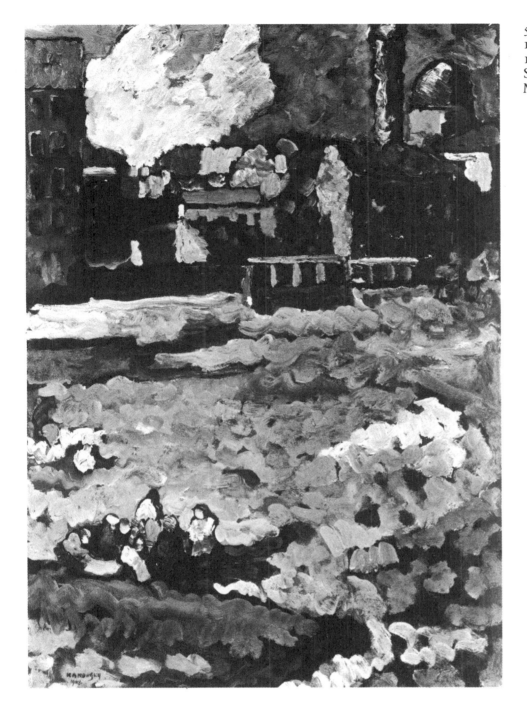

5 *Outside the town*
1908, oil on board
13 × 16¼ in (33 × 41 cm)
Städtische Galerie,
Munich

temporal modalities of universal laws in which the unconscious activity of the spirit consists, may help us to consider Kandinsky's conclusion to his important introduction to *Point and Line to Plane*: 'The problems of the science of art, which in the initial phase had been placed in narrowly and deliberately limited surroundings, surpass the limits of painting and art in general in the successive course of their development'. In fact *Point and Line to Plane* is written according to a method founded on the hypothesis of universal laws in thought. Naturally these hypotheses become concrete from time to time in the analysis of the techniques of the graphic arts, in the phonetic analysis of the rhythm of poetry, in the graphic interpretation of the lines of architecture in a comparative history of civilization, finally in the approach to the concept of interpretation in terms of line and colour as a codified function for every phenomenon in spite of every possible heterogeneousness in its origin (cf. Marisa Volpi, *Kandinsky,* 1968).

The phenomenon seen as an independent entity, valid *per se,* is returned to its pure essence in Kandinsky as in Klee through the process of anamnesis (though with different results) and it introduces us to the sphere of Husserl's phenomenology which is very remote from Bergson's thought. Husserl's

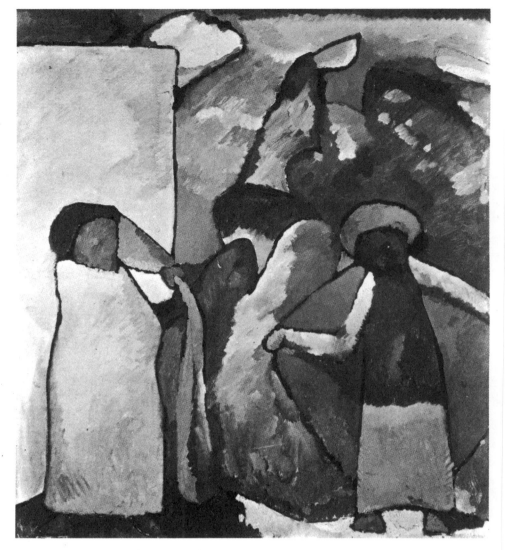

6 *Improvisation VI*
1909, oil on canvas
$42\frac{1}{4} \times 37\frac{1}{2}$ in (107·5 × 95·5 cm)
Städtische Galerie,
Munich

concept of period *(epoche)* creates a curious loneliness of thought; not in the sense of the Kantian *a priori,* or the functional law of the activity of the subject constituting experience, but in its 'pure essence' *(eidos)* which is offered to the intellectual intuition with the same objectivity and clarity with which a particular 'datum' of experience is offered to the sensible intuition.

In contrast to Husserl, his great disciple and dissenting critic Martin Heidegger assumes 'being in the world' as the fundamental theme of his researches, which begin with the basic text which he dedicated to his master; *Sein und Zeit,* 1927. The essence of being is existence, and existence is the moving of the being towards the understanding of the reason for its being. The spirit of Klee can be related to Heidegger; for him art has an irreplaceable and primary position and function; it is the first direct integral experience which is made of the world.

Husserl and Kandinsky

During the First World War, Klee worked on the creative confession which he made in 1919. From 1921 to 1931, during his Bauhaus period, he was writing his great theoretical work; he founded a science of art, studying step by step the genetic process of form *(Form)* and figure *(Gestalt)*; by figure he meant not the appearance of things but form considered in the notion of its development. The cosmos which he creates is always the cosmos which the artist creates in the form of his work; it has its own laws, its own contradictions; its structures, its rhythms; even art is thought and no thought can exist which is not thought concerning the world (cf. P. Bucarelli, introduction to the catalogue of the Klee Exhibition at the Galleria Nazionale d'arte Moderna, Rome, April–May 1970).

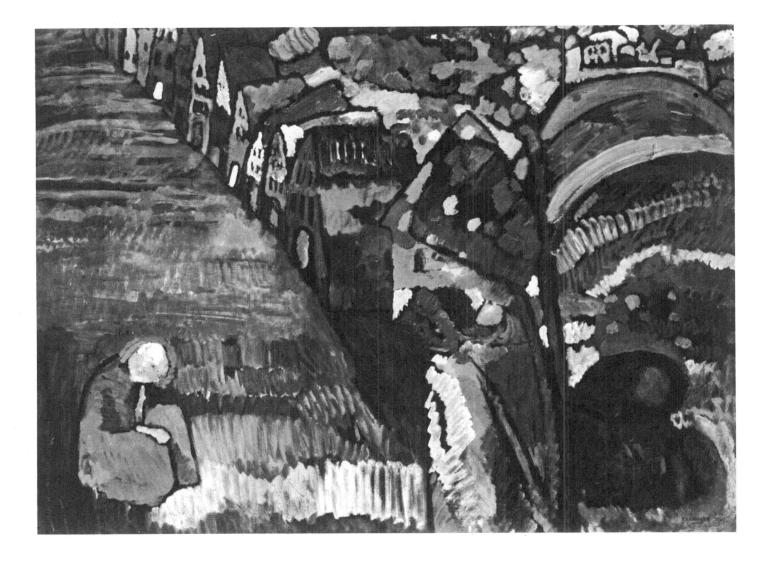

However the 'world of life' does not derive from a conception of the world, but rather the reverse, and on this point Klee disagrees with Kandinsky. Kandinsky had been the first to clearly distinguish the sphere of art from that of nature, but 'in the terms of a spiritualism which Kandinsky's dialectical reason could not accept'. The spirit of Faust in Klee made him unravel the profound and secret laws of the life of being, and his art, which is essentially and subtly graphic, and even interwoven in the most extraordinary planes of colour which reveal the light and shade of his nature, discovers the process of thought through images, 'showing that it is no less concrete, predictable and serious than thought-through concepts, and, like the latter, it is rigorous'. Kandinsky, who carried the 'mark of his personality with him' (to use his own term), aspired to translate the world of life from a conception of the world in his own mystical Russian nature. He too reveals himself—in his formative process—by graphic means, but music is undoubtedly the revealing element of the dynamic necessity of his line, of his moving forms in the measure of the spirit from which his conception of space is created and in the colour which fills the planes of the surface of his compositions and deepens its mystery. Even the 'achievement of numerical expression' which is revelation 'in music, and to some extent even in poetry, as well as in architecture' (cf. *Point and Line to Plane* pp. 100–101) helps him to deepen the sense of mystery which is in the life of being, which in its eidetic essence is the life of the world. The 'duration of time' is transmuted into his spirit in the infinite variants of the 'essence of the world'. Kandinsky's creative thought lies in his theoretical forms which are close to Husserl's ideas; his science is 'theoretical' (contemplative) and 'rigorous', that is 'founded' in the sense that it provides absolute foundations. It is an intuitive

7 *Houses at Murnau*
1909, oil on canvas
$38\frac{1}{4} \times 51\frac{1}{2}$ in (97 × 131 cm)
Stedelijk Museum,
Amsterdam

17

science because it aims to seize the essences provided for reason just as objects are provided for sensible perception. It is a 'non-objective' science because it is totally different from the other sciences which are concerned with physical or psychic facts or reality, whilst it puts aside every fact and reality and turns to essences. It is a science of origins and first principles because awareness contains the sense of all possible modes in which things can be given or constituted. It is a science of subjectivity because the analysis of awareness gives priority to the ego as subject (Nicola Abbagnano, *Storia della filosofia,* Turin 1966, III, p. 784–785). And the informing spirit of Husserl's thought becomes art in Kandinsky, or rather in the universal concept of the world: poetry. When we analyse his work we shall then discover how he began and proceeded within a historical period whose main principles we have now described.

Entering into a picture The seminal years of Vassily Kandinsky's youth were 1889–1895; during this period he started to become interested in art. In 1889 he became interested in folk art, and showed a passion for folk archaisms in their content and form; he found there a new and intense feeling which was crucial for the future development of his art. This was when he journeyed in the Vologda region on behalf of the Moscow Association of Natural Sciences, Anthropology and Ethnography. He states in a fascinating page of his autobiography, *Rückblicke* (Berlin, 1913. English edition, Hilla von Rebay, New York, 1945): 'Here I first learnt to look at a picture not only from the outside but to enter into it, to move around in it and to take part in its life. I happened to go into a room; and I still remember how I stood fascinated at the door and looked inside. There was a table, benches and a large, magnificent stove before me. The sideboards and serving-table were alive with many colours in confusion. Everywhere on the walls there were country prints which vividly depicted battles, a legendary rider, a song, all rendered in colours. In a corner there were many icons which gave forth dark glows and in front of these there was a lamp which appeared devout and humble, and at the same time proud and mysterious and appeared to emanate a warm twinkling of stars. When I finally came into the room I felt I was entering a painting and becoming a part of it. I had noticed this sensation before in some Moscow churches, particularly in the Uspinsky Cathedral and the church of St Basil, but unconsciously and confusedly. Only now for the first time I received it in its fullness.' These were the essential premises of Kandinsky's conceptions as a painter; here he sensed the 'third dimension' as an inner fact; later when he lived in Paris and Munich he developed this dimension and achieved a full creative reality in Munich in his Blaue Reiter period. The 'legendary rider' whom he saw at Vologda was an anticipation of the image he loved so intensely of his experiences as he showed in his 1903 painting *The blue rider,* Bührle Collection, Zürich, and the sketches and drawings for the *Blau Reiter* almanac.

Fig. 2 But the 1903 painting represents something more than a presentiment of form and colour in motion in relation to the surface of spaces and a certain depth already attained in the surface. We have not yet reached the 'third dimension' but its premises are revealed in the 'inner impulses' imprinted particularly in the foreground by the pictorial touches of colour in the intense punctuation of the form as 'fleeting', in the planes of the surfaces in which the small, fascinating picture of the rider in movement is vividly represented. Certainly in 1895, as Kandinsky said in his autobiography, when he saw Monet's *Les meules* in an Impressionist exhibition in Moscow, and when he heard Wagner's *Lohengrin,* he felt in his consciousness a latent impulse which was later to produce the marvellous achievements of his art. In his youth he thought a lot about French Impressionism and particularly Monet; for him it meant the phenomenal perception of colour and the draughtsman's mark (then so rigorous in the vision of Seurat) whilst the fascination of the young Wagner's musical invention in *Lohengrin* (which aimed a blow at hypocritical puritanism and exalted free sensuality, de-

18

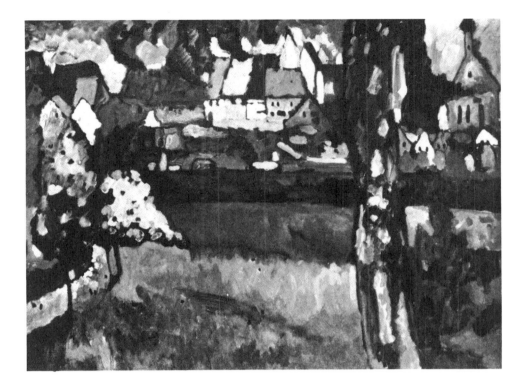

8 *Landscape with houses*
1909, oil on canvas
$27\frac{1}{4} \times 37\frac{3}{4}$ in (69 × 96 cm)
Kunstmuseum,
Düsseldorf

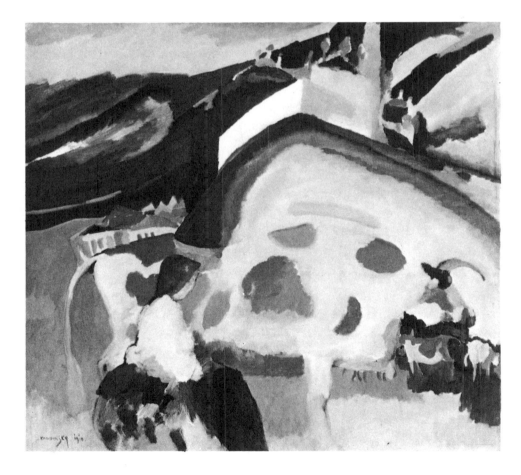

9 *The milch-cow*
1910, oil on canvas
$37\frac{1}{2} \times 41\frac{1}{4}$ in (95·5 × 105 cm)
Städtische Galerie,
Munich

nouncing the unnatural in moral laws and revealing new and expressive means of polyphonic instrumentation) can certainly be described as a deep and disquietening experience in his youth (Della Corte-Pannain, *Storia della Musica*, Turin 1944, III p. 1465). His spirit rebelled against petty bourgeois *(Biedermeier)* culture, which was characterized by the romantic German bourgeois who abandoned the heroic aspect of Romanticism and reflected its sentiments and ideas in domestic anecdotes with a certain intimate pictorial taste and delight in the ornaments of interior decoration. In particular, Kandinsky rebelled against professional art (which abandoned the spirit) and a facile and representational academic neo-realism. His love and interest in Impressionism and Pointillism was shown in the exhibitions organized by the Phalanx, a group which he led from 1901 to 1903; he also had a strong interest in Symbolism and Art Nouveau. Mallarmé's ideas also attracted Kandinsky: 'To allude means to suggest and this is the essence of the dream. The perfect use of this mystery forms the symbol. Gradually to evoke something to reveal a state of mind or on the other hand to choose something and to deduce a state of mind through a series of recordings', but the necessary experience is complex and was to be attained through the impulses of theosophical mysticism. He also felt the influence of Moréas, the Nabis and Maurice Denis, the Fauves, the Rosicrucians and German Expressionism.

It is difficult to define the most interesting factors in his experience which account for his maturity; he liberated himself from the influence of Fauvism, revolutionary as it was, and the archaic and allegorical symbolism in the representational and expressive depiction of the image. The years 1900–07 were rich in various experiences; Worringer published his *Abstraktion und Einfühlung*, which greatly influenced Kandinsky's theories; but these experiences were not decisive for his art, as can be seen in *Concerning the Spiritual in Art* which he wrote in 1910 and published in 1912. He had not freed himself from the 'iconographic' and representational elements of the image in relation to the countryside or to the 'surrounding dimension of the evocation of the image itself'. But his experiences were certainly interesting when we look at his painting even if they stem from various origins which did not stimulate the inner impulse towards a decisively new language. If for example one contemplates a painting like the *Couple on horseback* (1905), one sees he used expressive means derived from Seurat's chromo-luminarism and Van Gogh's Expressionist technique which are not decisive except in a dreaming and fabulous 'representation' in the composition, in which the evocative and descriptive accent of the image still prevails; in *Multicoloured life* (1907) this accent assumes the tones of a good-natured punctilious irony in the line surrounding the characters as though in the rhythms of a popular festival.

Towards abstraction

The Fauve experience which began in Paris in 1906 certainly led the way to greater freedom, which appeared in a revealing chromatic violence in the moving planes of the composition and in a more and more apparent reduction of representational elements, in which Kandinsky clearly intended to remove the suggestion of particular details. This tendency is illustrated by paintings such as *Countryside with bell tower* and *Blue mountain* (1909), *Composition II* (1910), *Improvisation VIII* (1910), *Improvisation* (1910), and *Countryside with two poplars* (1911). Kandinsky's first abstract is usually considered to be a 1910 water-colour; he reached abstraction through an intense and complex experience; the range of the visible was freed of all naturalism and showed him the primary evidence for his eidetic presences and essences through an internal dimension. It is clear that music had a great influence in resolving the problem of light and space in relation to colour and moving forms in the dynamic of line and the deepening of planes, in the absolute removal of every naturalistic content in *Improvisations V, VII, XIII, XIV,* and *XVI* and the wonderful *Improvisation XXVI* (1912) in the Städtische Galerie, Munich; (at this time Kandinsky was close to Klee

Pls. 3, 1
Pl. 6

Fig. 10

Pls. 9, 5, Fig. 12

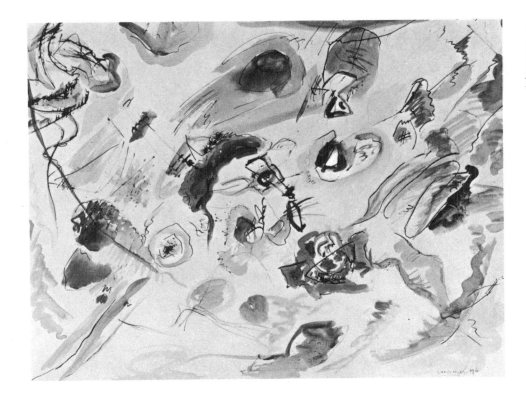

10 *First abstract water-colour* 1910, water-colour and ink 19¼ × 24¾ in (49 × 63 cm) Musée d'Art Moderne, Paris

and Marc in Paris, and Robert Delaunay was attempting with some hesitation to reconcile Cubism and Fauvism). But the important factor was Stravinsky with Diaghilev's successful Ballets Russes in Paris and Scriabin with his *Prometheus* with its sounds and colours. In 1913 Kandinsky gave the title *Sounds* to a collection of prose-poems with black and coloured woodcuts. Will Grohmann who wrote the most comprehensive and best documented monograph on Kandinsky (Il Saggiatore, Milan, 1958) considered that 'chromatic material becomes decisive as in music and in this respect Kandinsky stands between Mussorgsky and Scriabin'. The profound significance which Kandinsky found in Symbolist poetry is shown in the passages he devoted to the sound of words in Maeterlinck in *Concerning the Spiritual in Art* (Rome, 1940). Kandinsky wrote: 'The word is an inner resonance. This inner resonance partly comes (perhaps mainly) from the thing for which the word acts as a name. But when one doesn't see the thing itself and one only hears its name, the abstract representation, the dematerialized thing which immediately arouses a vibration in the heart appears in the mind of the listener. Thus a green, yellow or red tree on a meadow is not a material event, but a materialized fortuitous form of the tree which we feel in us, when we hear the word *tree*. The skilful use, in tune with poetic feeling, of a word, and its repetition out of inner necessity, two, three or more times running, may not only determine an increase in inner resonance but may also bring to light other unsuspected spiritual qualities of that word. Finally after the word is repeated many times, its pure sound is laid bare.'

Kandinsky pays a tribute to the affinity between music and painting when he quotes passages by Shakespeare and Delacroix: 'The musical sound has direct access to the soul. It immediately finds resonance in it, as man has music in himself (Shakespeare). Everyone knows that yellow, orange and red distill and represent ideas of contentedness, of wealth (Delacroix). These two quotations show the affinity between all the arts generally and particularly between music and painting. Goethe's idea that painting must have its own basis is certainly founded on this surprising affinity. Goethe's prophetic remark anticipates the situation in modern painting. This situation is the starting point for the development which painting with the help of its own skills, will pass through till it becomes an art in the abstract sense and finally attains pictorial composition'. Colour has a decisive influence on

Fig. 15

11 Original cover
of the *Blaue Reiter* almanac, 1912

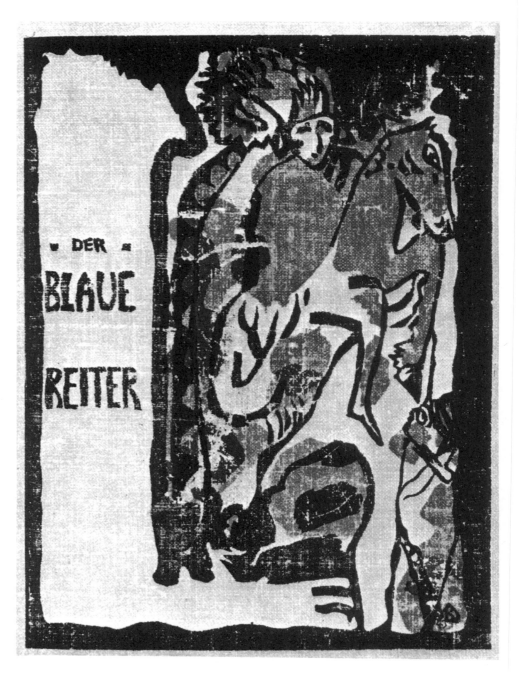

this goal. The following is one of the most fascinating passages in the analysis of colours in *Concerning the Spiritual in Art*: 'The tendency of blue to become deeper is so great that precisely in its darker gradations it becomes more intense and exercises a more characteristic inner influence. The deeper the blue becomes, the more it invites man towards the infinite and rouses in him a nostalgia for the pure and ultimately the super-sensible that is beyond the senses. It is the colour of the sky as we imagine it when we hear the sound of the word 'sky'. Blue is the typically heavenly colour. If it is very deep, blue develops the element of quiet; if it goes as far as black, it acquires an additional resonance of non-human mourning. It implies an infinite deepening in those states of mind of seriousness which do not have and cannot have an end. If blue becomes lighter, which it is less suited to, it acquires a more indifferent character and remains distant and insensitive to man, like the lofty blue sky. The lighter it becomes therefore, the more it loses resonance, until it turns to a mute stillness: it becomes white.' This is the high point of abstraction, what Husserl would call the purest stage of the eidetic essences, and Shakespeare 'the silence'. Not even Kandinsky dared to penetrate the full domain of abstraction which evolved in the Blaue Reiter group.

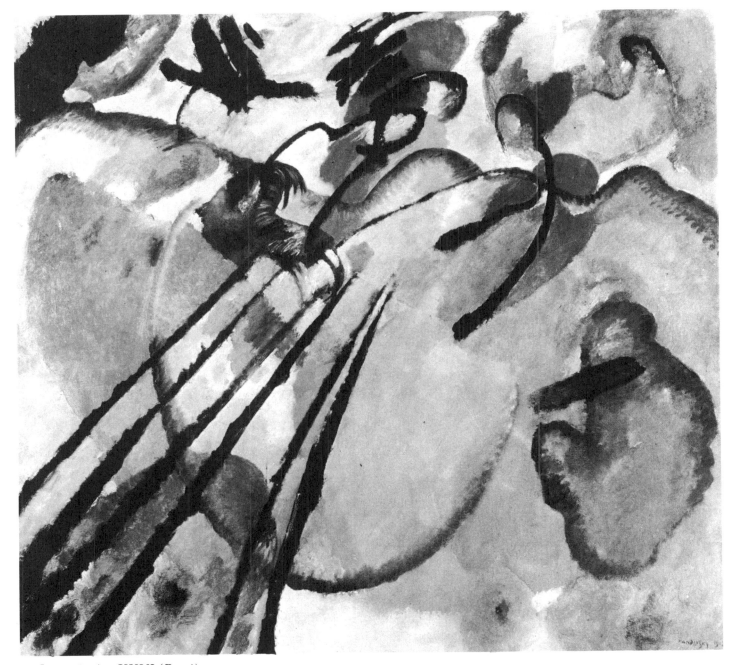

12 *Improvisation XXVI (Remi)*
1912, oil on canvas
$38\frac{1}{2} \times 42\frac{1}{2}$ in (98 × 107·5 cm)
Städtische Galerie,
Munich

14 *Study no. 7 for Composition VII*
1913, water-colour
Städtische Galerie,
Munich

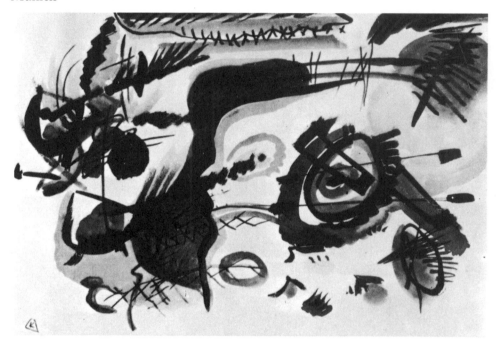

The Blaue Reiter

The progress of the Blaue Reiter group is complex, profound and rich in the dimensions of the spirit. In particular it contained the contradictions which were resolved in the experiences of iconography and symbolism and the language of German Expressionism.

In his path towards pictorial abstraction Kandinsky was stimulated at first by his cultural and artistic interests, to which we have already referred, and which in the course of time had a profound influence on his thought. In the field of Symbolist poetry Kandinsky had, in his *Concerning the Spiritual in Art,* noted eschatological allusions not only to theosophy but also to mathematics; he observed the harmony in painting, its relation to music, the mystical content of art and the symbolism of colours. He himself strove to find a harmony and an objectivity in art, concerning which Denis had already written interestingly in *Définition du Néu-traditionalisme* (1890), when he mentioned 'pictorial signs or equivalents without it being necessary to copy the initial optical spectacle'. Dujardin, four years earlier (1886) wrote the article 'Le cloisonnisme' in the *Revue Indépendante* which touched on the subject.

Dujardin insisted that the object of painting and literature was to give the sensation of the objects through their meanings which are specific to painting and literature; he emphasized that it was necessary to choose the essential element and produce it rather than reproduce it and that a diagram was

24

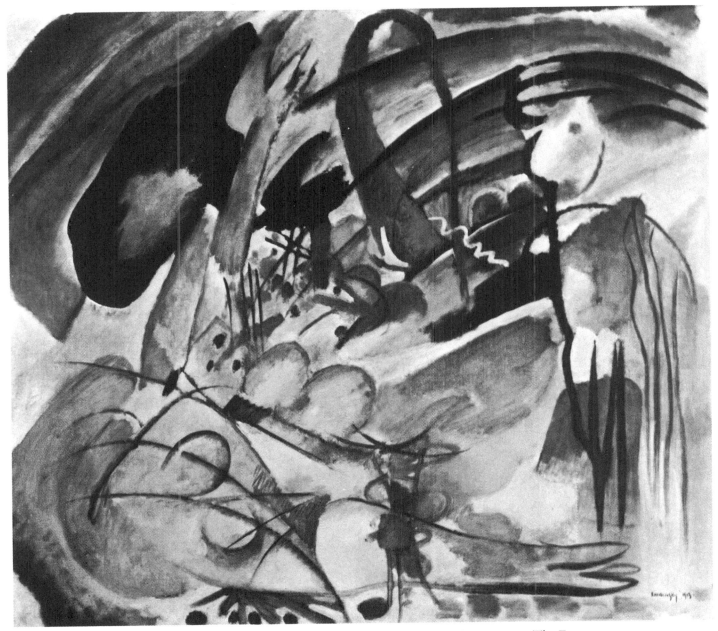

13 *The East*
1913, oil on canvas
$34\frac{1}{2} \times 39\frac{1}{2}$ in (88 × 100 cm)
Stedelijk Museum,
Amsterdam

Fig. 11

sufficient to represent a face, as 'primitive art and folklore are symbolical in this way'. It is interesting to note in his ten sketches for the *Blaue Reiter* almanac how Kandinsky succeeded in making works of art from these ideas twenty-five years later, in 1911 and 1912.

The foundation of the New Association of Munich Artists in 1909 anticipated the Blaue Reiter movement; at its second exhibition it attracted the attention of Franz Marc who was already interested in the Fauves. Kandinsky's friends included Jawlensky, Werefkin, Gabriella Münter, Alexander Kanoldt, Adolf Erbsloh, Alfred Kubin, Giriend, Le Fauçonnier, Alexander Sacharov, Karl Hofer, Paul Baum, and Vladimir Bectejeff; but he formed the nucleus of the Blaue Reiter with Jawlensky and Marc. This term referred to the group of painters who exhibited, as well as to the almanac published in 1912. In 1910 plans were made for a review called *Blaue Blätter* (Blue Pages) to conduct an artistic battle on the basis of a spiritual renewal. The battle provoked opposition and polemics on the part of men with old fashioned ideas.

In 1911 Kandinsky's *Composition V* was rejected for the third exhibition of the New Association of Munich Artists under the pretext that it exceeded the prescribed dimensions. Kandinsky, followed by Marc, Kubin, Münther, Jawlensky and Werefkin left the Association; Hugo von Tschundi, the director of the Munich National Museums, then gave his support to an

25

exhibition at the Tannhäuser Gallery which became famous. It was the beginning of the Blaue Reiter.

The image of the horse had remained in Kandinsky since his distant childhood (cf. his autobiography); the motif of the rider persisted in his painting from his Symbolist and his abstract period as a romantic talisman of the galloping hero, the Rosicrusian knight, Siegfried, who cannot be stopped by death nor the devil; these symbols, from fortune-telling and the popular epic of the *roman de geste* can be reinterpreted as the triumph over matter, in the disc which symbolizes the sun and in the image of the rider which shows the fatal and occult action of cosmic forces. This symbolism is expressed by Kandinsky most interestingly in the graphic-pictorial language of the sketches of 1911 for the *Blaue Reiter* almanac (now in the Städtische Galerie in the Munich Lenbachhaus) in his development from the representational to the abstract (and particularly in some tempera on glass for his figurative pictures); this shows that Kandinsky reacted more and more decisively against German Expressionism, which was led by Otto Dix and George Grosz, and against the Brücke movement which preceded it.

The graphic arts, that is engraving, wood-cutting, etching, and lithography, are certainly the 'true field of artistic greatness, the heritage of those artists whose work in Germany can be defined as expressive', the 'seal which has remained peculiar to it, giving evidence of its creative energy' in the 'crudeness and violence of oppositions . . . And the cities change, become anonymous; biblical arguments and exotic themes assume a new appearance and where the dreams of painters are materialized as in Klee's 1922 lithograph, *The witch with the comb,* where the animals, the ghosts or the exotic elements break into the limits of the paper, a new vision is described, a new space is gained for the art of our century. Whether it is a brief note in lines or a cyphered figure which is freed from the ink and then plunges again into darkness, whether we see a figure which entirely fills the picture or the artist's sheet (as often in Beckmann's etchings), whether we are obliged to review the grouping or the human features of the painted characters, something is always said convincingly, something which manages to stimulate the observer's imagination' (from G.C. Argan's introductory essay to the catalogue of the Exhibition of Graphic Arts in German Expressionism, Rome, March–April 1970). All this represented for Kandinsky a remarkable experience, although he did not share it in its fundamental aspects, particularly in painting, for two reasons. Kandinsky ignored and disliked social polemics because they were crude, violent and distorted. His deepest vocation was the liberation of the spirit from the roots of evil through impulses that strove to find the pure eidetic essences. These emerged from a phenomenal perception of form in the gradual passage from representational depiction and Abstract Expressionism to the achievement of the purest abstraction. Colour has a fundamental role in Kandinsky's work and comes from his Fauve experience 'which derives from Impressionism and defines every value by comparing it with the white, that is, light, whilst the Expressionist theory defines every value in relation to black, the shadow' (G. C. Argan, op. cit.).

Jean Leymarie, in his essay on French Impressionism in the introduction to the catalogue of the exhibition of European Expressionism (Paris 1970), discusses a fascinating problem of contemporary art: 'Expressionism represents' he wrote, 'one of the decisive poles of our time, a dramatic reply to our existential condition and to its profound anguish. It is the mad cry of anguish exasperated by social crisis, psychic tension, spiritual bewilderment; the modern anguish identified by Kirkegaard in the syncope of freedom, by Heidegger in the revelation of being in the world.' And whilst Klee moves in the spirit of Heidegger's thought, Kandinsky renews his religious mystical origins in Husserl's consciousness as an inner dimension and eidetic essence of being in phenomenal reality; in transition from lower or passive forms, the traditions and habits or memories which inhibit man's freedom (which Husserl calls Dasein), to the higher forms in which freedom becomes

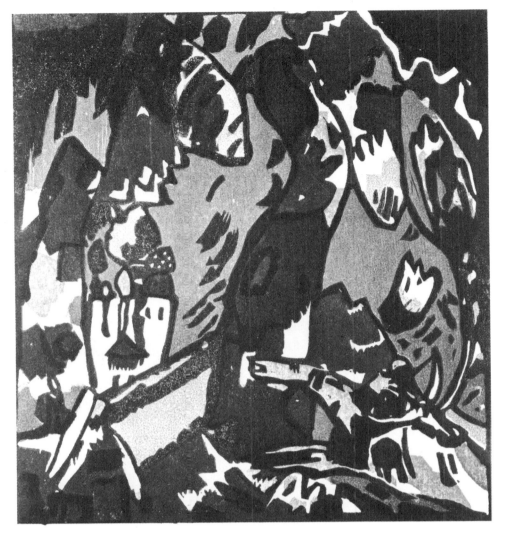

an act in its supreme mood, creation.

Creating in the cosmological version is different in Klee and in Kandinsky, but neither of them want to 'assume like Mondrian, an ideal society which is finally pacified in the common acceptance of incontrovertible rational truths' (G. C. Argan, *Salvezza e caduta nell'arte moderna* cit.). And whilst Klee 'prefers to seek motives of understanding in lived experience in the history and pre-history of humanity', Kandinsky looks for them in the internal structures of the moving spirit, in their fundamental relationship to consciousness itself, in their illuminating liberation.

In his Blaue Reiter period Kandinsky became acquainted with Schoenberg's work and found a creative vitality in all artistic circles. He was compelled to create poetry (*Sounds* was published in 1913) which was of interest to the Dada movement. Hans Arp, as Marisa Volpi remembered in her monograph on Kandinsky, noted in Kandinsky's poetry what might have been a lyrical version of a play for the theatre, or of one of the four paintings he completed between 1912 and 1914: 'In these poems there is a breath from strange unexplored depths. Powerful forms arise like speaking mountains. Stars of sulphure and poppy flourish on the lips of the sky. Human shadows materialize in magic mists. Clods of earth wear ethereal shoes. From the sequences of words and sentences of these poems, the reader is summoned to a continuous fading away, to a perpetual growth of things, with often a dark humour'. 'The hidden construction', wrote Kandinsky in *Concerning the Spiritual in Art*, 'may result from forms apparently thrown on to the canvas at random and which in their turn do not appear to stand in any mutual relationship; in this case the outer absence of this relationship constitutes its inner presence. What is externally slackened is here what is

An important and precise relationship

16 *Improvisation without title*
1914, oil on canvas
$29\frac{1}{4} \times 49\frac{1}{4}$ in (74 × 125 cm)
Städtische Galerie,
Munich

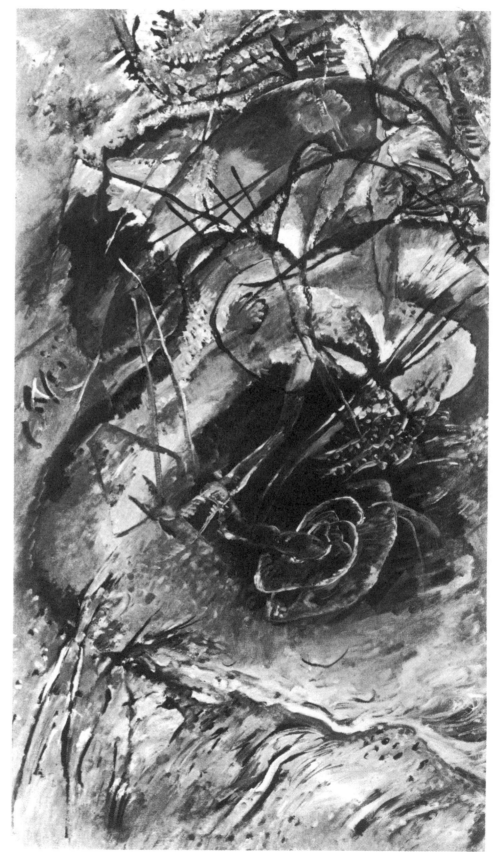

internally fused together. And this is true for both elements: the form that is drawn and the form that is coloured. The forms which are random are finally in an important and precise mutual relationship.'

We may note what Kandinsky himself wrote: 'A large acute-angled triangle divided into unequal sections, with the narrowest segment uppermost; thus one can see the spiritual life properly and in diagrammatic form. The whole triangle moves slowly, almost invisibly, with a progressive rising movement, and tomorrow, at the place where the vertex existed today the first section will be found. What is incomprehensible idle talk for the remainder of the triangle will tomorrow become the content of life, full of sense and feeling. At the top of the vertex there is sometimes a man by himself. His cheery vision is like his inner incommensurable sadness. And those who stand nearest to him do not understand him.' Up to the outbreak of the First World War, new forms with fawn-coloured spots tending towards the abstract appeared in Kandinsky's paintings. The flat surface regained the depth of space in the spots of colour, and its rhythmical dilatation is moved by the instrumental counterpoint of the lengthened converging and diverging marks which it animates and intensifies. In the years 1915–21 Kandinsky's production was rather small but his mind was moved by new experiences which made him ready for his future activities at the Bauhaus; these were to include the *neue Sachlichkeit* in the field of literature and drama and the twelve-tone scale in music.

From 1918 to 1921 his activity as a painter was limited, and Kandinsky devoted almost all his time to intensive social activities to which the Soviet regime summoned him. He devoted himself passionately to these, holding

The lining in the sky

17 *Without title, called Flood*
1914, oil on canvas
$42\frac{3}{4} \times 55\frac{1}{4}$ in (108·5 × 140 cm)
Städtische Galerie,
Munich

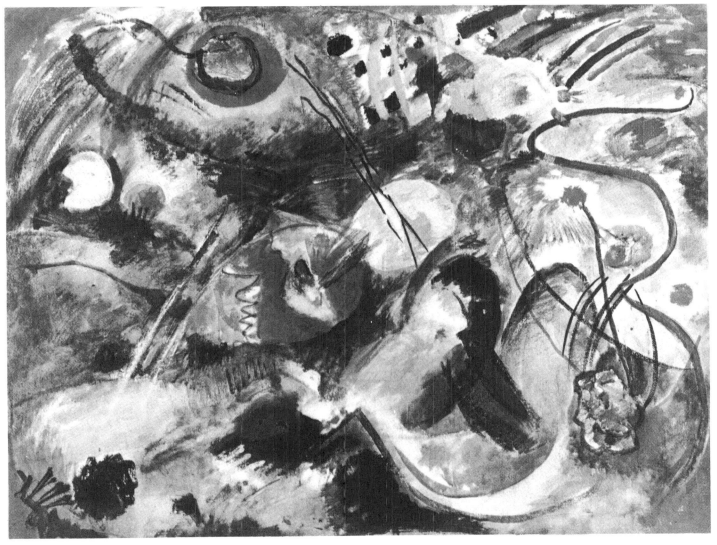

high positions at the Commissariat for Intellectual Progress, at the School of Art and at Moscow University; moreover he established twenty-nine new provincial museums.

His experience of leading Russian art movements, Malevič's Suprematism and Tatlin's and Pevsner's Constructivism was crucial to his development. Above all, Malevič's personality was interesting compared with his own, for Malevič's theories not only reflect some of Kandinsky's views clearly but they have in common with him a kind of deepened spirituality which reaches the apex of sensibility in the famous *White square on a white background*. This is the apex of a spiritualism which Kandinsky had not attained in his work as an artist, but which he had anticipated in a fine passage in *Concerning the Spiritual in Art,* and therefore before Malevič himself had exclaimed (in 1915): 'I have seen the lining in the coloured sky, I have torn it away, I have tied the knot in the sack which has formed. Swim! The white, a free abyss, the infinite wait for you.' Even before 1912 when his book was published, Kandinsky had written: 'To be precise, white, which is often not considered a colour, particularly by the Impressionists who see nothing white in nature, is like a symbol of a world in which all colours both in their material qualities and substances have disappeared. This world is so high above us that we cannot hear any sound issuing from it. On the contrary, a great silence comes from it which when represented as matter, appears to us like a cold, invisible, indestructible wall which is infinitely prolonged. For this reason white acts on our psyche like a great silence which is absolute for us. Within us it resounds like a non-sound rather similar to some pauses in music, these pauses which only temporarily interrupt the development of a phrase or a motif and are not the definite conclusion of a development section. It is a silence which isn't dead, but is full of possibilities. White resounds like a silence which can unexpectedly be understood, it is a blank which is juvenile, or better still a blank which is before the beginning, before birth.' Malevič was the most interesting person Kandinsky could have met in Russia; he did state in *Point and Line to Plane* that the Russian Constructivist tendencies were basically foreign to him (the reasons are obvious) and Suprematism as a theory only interested him comparatively little. However, Malevič's thinking and style were in some respects so close to Kandinsky's that his influence was evident in some of Kandinsky's important mature works. (This was immediately after he studied Léger's works).

Kandinsky and Malevič

From 1910 to 1930 Russia was an extraordinary promoter of ideas in the field of art, the theatre, literature and the cinema; it was also the first nation in the world to officially exhibit abstract art between 1918 and 1920 in the new thirty-six museums opened by the Directive Committee. In the first issue of the *Soviet Review*, Malevič wrote an important essay *From Cézanne to Suprematism,* seeing artists as philosophers seeking the truth; this truth is so much in accordance with their work that it reveals the work's essence. When we look at Malevič's ideas again we not only observe their clarity but bearing in mind Kandinsky's work, we notice various points of correspondence between the two painters. A good example of this is Malevič's remark: 'The artist must sow the painting so that the object as such dies, as the painting which the artist has felt grows in it. But if a well-polished basin and a pumpkin, a vase, a pear, a jug begins to gleam instead of the painting, we shall have a flower-bed on which nothing has grown.' Painting finished as a story and as a pictorial art in the work of Kandinsky and Malevič in the same years, beginning in 1910 and finishing in the case of Malevič in 1920. 'Art invades spaces where only form exists'. Again Malevič in his essay in *Soviet Review* briefly reviewed with his acute and lucid intelligence some basic stages of what might be called the sources of modern art: 'Monet looked for the basis of pictorial art in shade and light; in the paintings of Cézanne there was volume; the weightiness of the object which Picasso succeeded in developing achieved a monumental and dynamic effect; the

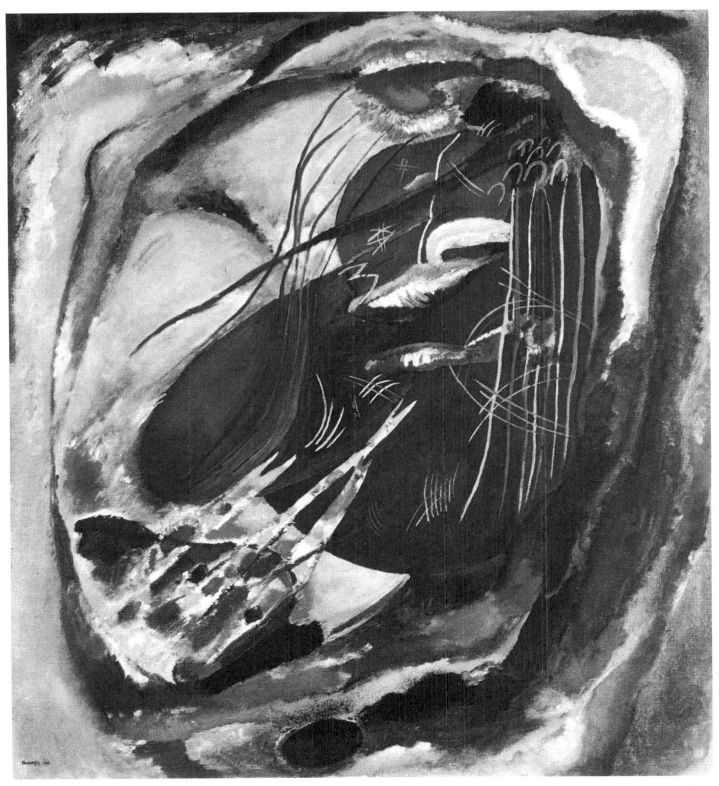

18 *Square with three spots*
1914, oil on canvas
$42\frac{3}{4} \times 46\frac{1}{2}$ in (108·7 × 118·5 cm)
Guggenheim Museum,
New York

latter is so intense that painting itself appeared to die out. Futurism abandoned all the distinctive marks of the green world, the flesh and bone, and revealed a new mark, the symbol of speed which is prepared in millions of forms to run on the new shores of the future and merely due to a still uncertain grasp of reason runs within the world and devours all that comes its way as though satisfying its own feelings with a long journey'.

The 'principle of the inner impulse as the unique unalterable law of art in its essence' is a quotation from Kandinsky's introductory essay in the catalogue of the *Salon* of the second international exhibition held in Kiev, Odessa and St Petersburg in the years 1910 and 1911. When Kandinsky's statement is analysed, the areas of agreement and disagreement between him and Malevič appear clearly.

Kandinsky wrote: 'These two elements colour and line, constitute the essential eternal immutable language of painting. Every colour considered separately and assimilated in similar conditions, cannot fail to arouse a unique and identical spiritual vibration. But in fact it is impossible to isolate a colour and therefore its intimate absolute vibration always varies according to various circumstances. The important circumstances are: I, the nearness of another shade of colour; II, space (and its form) occupied by this shade.' Malevič's theories clearly resemble some of Kandinsky's, beginning with a 'sensibility to the object's essence'; at the same time Kandinsky's colours and the dynamic rhythms of the forms expressing them, even in the subsequent Blaue Reiter phase, which is similar to the dynamic aspect of geometrical Suprematism, emerge from the source of the world as living ideas, beings of pure reason. Malevič absorbed Léger's Cubist experience, which is a dynamic of plastic forms interpenetrating in movement; when it began it particularly interested him. After his Cubist-Futurist pictures of 1911–12, he made use of his plastic sense but within it he 'created the dynamic calm of the visible' and reached the apex of the inner dimension of his consciousness, that is the 'white forms against a black background' (K. Malevič, *Manifesto of Suprematism*).

Léger, Mondrian and Miró
The origin of Malevič's experience is in Léger's paintings of 1910–13 which are splendid examples reaching more and more openly towards abstraction, if one examines the following paintings in their order: *Les nus dans la foret,* 1910, *Les fumeurs,* 1911, *La femme en bleu,* 1912, *Modèle nu dans l'atelier,* and *Contrastes de formes,* 1913. Whilst Delaunay followed the Impressionists in their use of complementary colours, Léger perceived the function of vertical lines contrasting with masses of curves in a juxtaposition of intersecting planes attracting the spectator's glance in a continuous movement. This was Léger's original contribution, though his roots are in Cézanne. Picasso had developed his analytical and synthetic Cubism from the *Demoiselles d'Avignon* in a different way. Malevič on the other hand was influenced by Léger whose theories run parallel at this time with those of the Blaue Reiter. Kandinsky, in the period succeeding the Blaue Reiter, after a few years of reflection, turned his attention to the experiences of the Russian avant-garde (Pevsner, Gabo, Malevič). He found the need to develop his artistic language in design, in the concept of the functional nature of agreeable art in Tatlin, Rodzenko, Popova, Exter and Stepanova. This paralleled Malevič's development in 1915–20.

Pl. 27
The most interesting works in this new stage of Kandinsky's development were painted in 1920–27, up to the painting, *Square* of 1927; this work shows a need for experience expressing and communicating movement similar to that of Mondrian, anticipating Vasarely's language in the third dynamic-geometrical dimension of the planes of short strokes and light. Kandinsky's previous works, such as *White stroke* (1920), *Circles in black* (1921), *Blue circle* (1922), *Composition VII* (1923), *Accompaniment* (1924), and *Black relation* (1924) have their antecedents in David Burlink (*Spring,* 1913), A. Rodzenko (*Abstract composition,* 1918) and particularly K. Malevič's (*Suprematism,* 1915). There is a latent affinity of sensibility and thought in

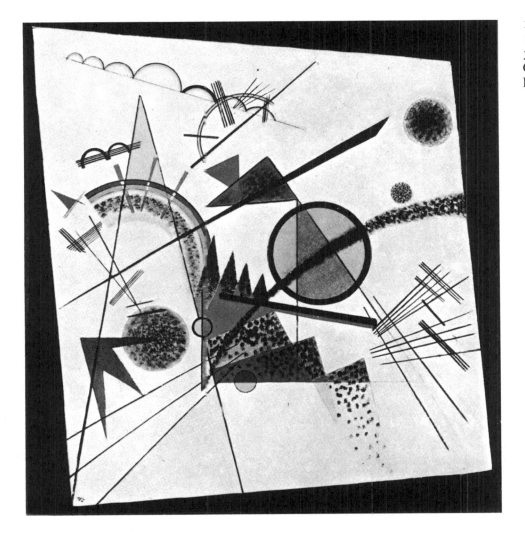

19 *In the black square*
1923, oil on canvas
38¼ × 36½ in (97 × 93 cm)
Guggenheim Museum,
New York

Malevič and Kandinsky which brings them together, even though the two painters developed differently. This is closer than the affinity between Malevič and Mondrian. Mondrian represents space no longer in the illusion of depth but in the sureness of the plane. Thus he also opposes the threatening suggestion of the unconscious and the irrational which only concerns a magical and mystical aspect of the themes of Surrealism. Later Kandinsky found links with the typical images of Miró. He showed the deep layers of a pre-existential perception, which created the mysteries of the world, and completed paintings like *Silence* in 1926 and *Hardness* in 1927. In 1922 Mondrian invited Miró to exhibit in Paris with the Abstraction-Creation group. Miró refused to get mixed up with the 'abstractionists' and wrote: 'If the marks which I transcribe on the canvas at the moment when they correspond to a concrete representation of my mind were not profoundly real, they would not belong essentially to the world of reality. The fact is that I am in the process of attaching greater and greater importance to the content and themes of my work'. But Mondrian opposed a rigid defence of pure reason to the tragic element of feeling and passion: man has not yet realized his rational ideal, but he will have to realize it because this is his only salvation; all that is not rational removes him from salvation, drives him to the abyss and is the cause of tragedy. The crucial experience which causes the explosion of the extraordinary proliferation of Miró's images is Surrealism and even earlier, Dadaism. Arp with his biomorphism offered Miró the key to the problem. Arp's form, as the form of an organic principle is as absolute, basic and constant as Mondrian's geometry, as the form of a rational principle. It is a different principle, psycho-physical rather than spiritual, but it is always a principle; for this reason Arp has no difficulty in belonging to the De Stijl movement. Miró goes beyond the schematism of equivalence and of the antithesis of the organic and the rational; he goes beyond the visionary surrealism of Max Ernst, Kandinsky's spiritualism,

20 *Pink square*
1923, oil on canvas
41 × 37¾ in (104 × 96 cm)
Marlborough-Gerson Gallery,
New York

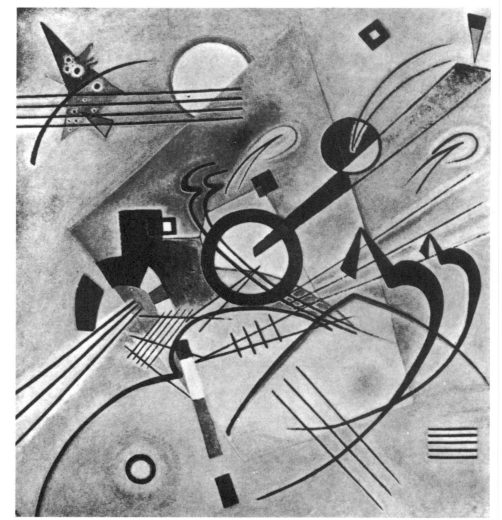

Picasso's mythologies (G. C. Argan, *Salvezze e caduta nell'arte moderna* cit.).

Wealth of motivation
The biographies of Kandinsky state that in 1925 he met Ensor while travelling in Belgium; in 1934 he met Miró, Delaunay and Mondrian, and became friendly with Pevsner, Arp, and Magnelli. But when we compare a work of Kandinsky's painted in 1925, *Yellow-red blue* with a work of 1926, *Silence,* we notice a fundamental difference in composition and expression in relation to the content. In the first painting, the graphic, dynamic and geometrical elements are brought together in a rhythmical relationship with a fascinating note of inner evocation; they emphasize musically the depth of the colours in relation to the space which is being created; in the second, Kandinsky stresses and reabsorbs the graphic and geometrical elements of form in the chromatic material of his inner dimension which emerges from the background in dense luminosities rarefied by light and darkness. It seems that elements from Miró and Arp have become ingrained in his imagination in a magical-surrealistic language, discarding every representational hypothesis with a poetic evocation of dreamlike contents transfigured in an abstract and rhythmical essence of expression. The graphic

34

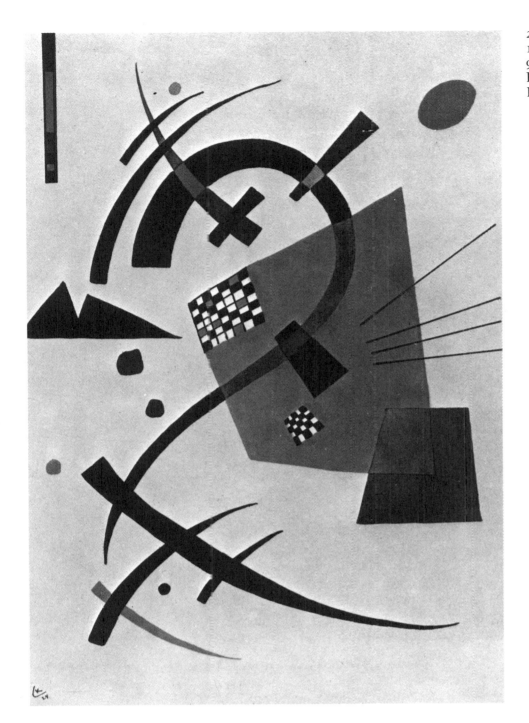

21 *Composition*
1924, oil on canvas
$9\frac{1}{2} \times 14$ in (24·5 × 35·5 cm)
Private collection,
Rome

automatism of Surrealism did not dominate him; on the contrary he rejected
it decisively in *Some circles* in 1926. Fig. 22

 Surrealism started with the premise of an objective separation and an
insuperable antagonism between the domains of the conscious and the
unconscious; it claimed freedom and authenticity for the unconscious; the
unconscious could be revealed in a dream, when the vigilance of the psycho-
logical and social censors slackened (G. C. Argan, *Salvezza e caduta nell'arte
moderna* cit.). In *Some circles* and in *Intense black,* Kandinsky showed clearly
that he wanted to get rid of the misleading authority of Surrealism and
return to the primary authority of the spirit; Malevič went through a
similar phase. Kandinsky's work shows a phase of interesting mediation
between the dream authority and that of the primary essence in *Soft hardness*
(1927), and a more clearly liberating phase in *A circle A* (1928), where he is
closer to Malevič. There are hints of Klee and Malevič in *Eight times* (1929)
and in *Grey arrangement,* (1931). He shows geometrical elements ingrained
in an original expressive romanticism which obliterates the last traces of
shadow in an evocative immersion of planes that are either light coloured
or slightly subdued in *Development in brown,* (1933). In *Trick riding,* (1935), Pl. 37, Fig. 26

35

biomorphic elements from Arp return to a rhythmical and pure instancy of design and primary colours in the context of the composition, open to the measurement of a space which suggests the contemplation of the infinite. In *Black points* (1937), the infinite is moved by the breath of elements (which resemble those of Calder today) in relation to geometrical themes which space seems to reabsorb in the dialectic of the colours, russet brown; violet grey, blue green, maroon yellow, with the black, expansive punctuation of the draftsman's mark. In *Green sonority* (1936), there are elements of a full drawing on the surface as though summarized in an ancestral memory, or better, through a suggestion of ancestry from Art Nouveau and taken up again in an eidetic dilation of Arp's biomorphic vision. On the other hand in *Relationships* (1934), Arp's biomorphic elements appeared to be mediated by Miró's fantastic vision and punctuated with a wealth of evocative and descriptive movements and of rhythm.

Up to the time of his death in 1944 in Neuilly-sur-Seine, a Paris suburb, Kandinsky's work showed a wealth of inspiration. This might appear contradictory if one were to forget his extraordinary capacity for intellectual absorption and his inner need to expand the range of his thought and sensibility by drawing continuously from the mysterious depths of his subconscious. To the last days of his life Kandinsky was planning works connected with the dance and music; his initial romantic impetus was clarified in the 'vision of complete art', as he loved to call it. Even if in 1938, in the painting *An arabesque,* he was still tempted by Mondrian, he wanted to bring his artistic impulse closer to Malevič. Works such as *The whole* (1944), *Various actions* (1941), *The arrow, Division-unity, Circle and square* (all 1943), and *Moderate impulse* (1944), give evidence of the continuously growing osmosis of his mind between a primary need for mathematical and geometrical order in his expressive means and a vital inner dimension of his creative impulse which brings a magical movement to forms. His intensity would be found surprising if one did not remember that it sprang from a vision of reality that was ingrained in his mind as a solid base for his principles and his theoretical development which always advanced, particularly in his period as a teacher at the Bauhaus. Kandinsky stopped at the threshold of the unconscious, carried decisively away from Surrealism by a new myth of reality; his drawing for a *Fluctuating figure* (1943) is there to prove it. It would have been extremely dangerous for him to go further, and it would have been against his essentially spiritual nature. His nature in spite of ideological conflicts had profound affinities with Klee, and at the most sublime moment of his inner consciousness he felt Malevič's greatness.

Kandinsky and Surrealism

It would indeed be quite mistaken to consider Kandinsky to be at the boundaries of reason and consciously immersed in a paradox of the irrational, as though he were the poet of a metaphysic of the dream lived as a substitute for a reality and unity impossible in life. Even when Kandinsky used abstract expressive means that were subtly surrealist, in the last period of his life, these means show a very different inner dimension compared with the intentions and dreamlike methods of Surrealism; in Surrealism there is a continuous thread of alarms from the representation of nudity, which is dreamlike and unhealthy in Delvaux's paradox (inspired by Gerard de Nerval) 'the dream becomes world; the world becomes dream') to the de-mystifying possibilities of the world of nature and the feelings of Dali. The substance of a nature which is preparing something, where in Max Ernst the unknown is related to the knowable, cannot hynotize Kandinsky, but on the boundaries of the unknown he shows a subtle and delighted irony in the immediacy of a lyric heard at its beginning which is close to Miró. But undoubtedly there is fundamentally something still deeper in the counterpoint of colour and in that absolute, almost mathematical rigour he has from Arp, which is liberated in space. We might say with Merleau-Ponty (*Il visibile e l'invisibile,* ed. C. Lefort, Milan, 1969) that the invisible is not merely a caress, a gap in the close web of the visible, but much more: it is

Fig. 27

Pls. 46–47
Fig. 29

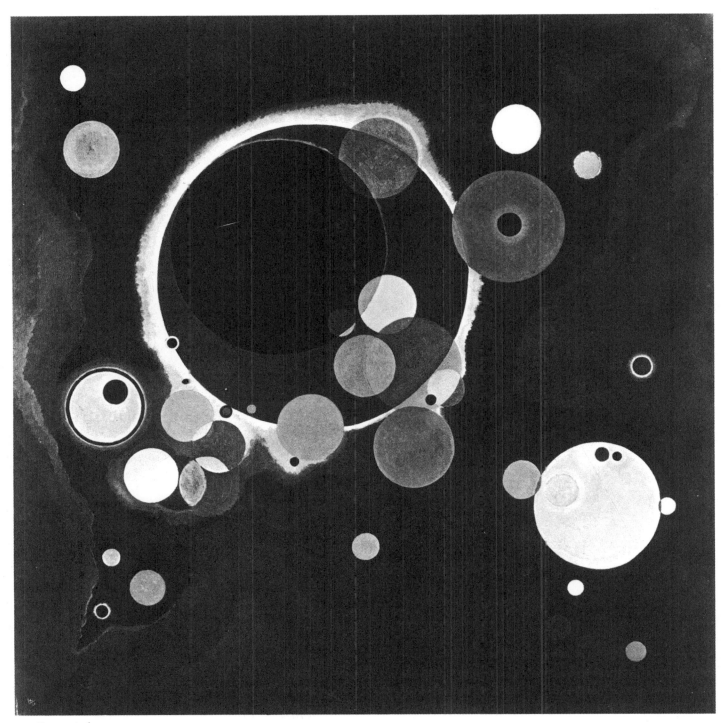

22 *Some circles*
1926, oil on canvas
$55\frac{1}{4} \times 55\frac{1}{4}$ in (140×140 cm)
Guggenheim Museum,
New York

24 *Sharp into soft*
1929, oil on board
$19\frac{1}{4} \times 19\frac{1}{4}$ in (49 × 49 cm)
Musée d'Art Moderne,
Paris

23 Design of scenery
for *Pictures from an Exhibition*
by Mussorgsky,
1928

something which implies the visible as an alternative. In this context the relationship of thought and art in Kandinsky must be reconsidered, particularly in its relationship to German Expressionism.

In Kandinsky and Klee the graphic arts of German Expressionism undoubtedly had a positive influence since 'the artist through his slow and tedious labours as an engraver became aware of his own original essence' and because 'a new value of space, as Klee understood it, was able to preserve the draughtsman's mark, an almost invisible creature from the furies of the introspective emotions' (I. Mussa, 'La grafica dell'Espressionismo tedesco', in 2 Punti, April–June, Rome 1970). Kandinsky, like Klee, is on the other hand at the opposite pole to German Expressionist painting, particularly in the field of social and political action and their symbolic representation. Neither Kandinsky nor Klee approached the 'expressionistic psychoanalysis' of other painters and writers. Their work does not finish in 'gigantic shadows, horror, certainty: it is finished it is death'. The work of Kandinsky and Klee, although their language is quite different is very subtly adapted to the spirit that unites them, and approaches a profound salvation; at its foundations it is most mysterious and sublime and it arises from an inner introspection in which 'art is thought and thought can no longer exist which is not thought concerning the world'. Here both painters differ from the poetics of Surrealism. 'Even Klee, though he was hailed as a comrade of the French Surrealists, differs from the poetic theory of Surrealism; he does not attempt to bring the unconscious to the surface but to truly touch the bottom, the beginning' (P. Bucarelli; Klee, introductory essay to the catalogue of the Klee Exhibition, National Gallery of Modern Art, Rome 1970).

There is an order in the inner structure of Klee's images, and light comes from his thin moving designs and his coloured spaces. His inner structure is decisively opposed, although with great and subtle courtesy to all that is chaotic and convulsed, to all that belongs to the world of alienation. This is the most intimate and secret aspiration of the poetics of Musil and his heroic sense which refuses to give in to the characteristic dissolution in Joyce, although Musil examines it closely. The man 'without qualities' (the expression is ironical, because he really has qualities in comparison with men who claim to have them) lives at the heart of a society, aware of its nature and its undertakings. Musil's attitude is not that of a positivist, but of a scientist who has lived through the crisis of the mechanistic image of the world and sees the principle of indeterminacy starting everywhere. This is why the small, humble and so intimately great Faust of Kafka who has a secret desire to rediscover order in the family, in society and in his own interior ego exclaims: 'I can only find happiness if I can raise the world up to the pure, the true, the immutable . . . Heavy torrent of rain. Put yourself against the rain, let yourself be soaked by fierce water-jets, slide into the water which is trying to drag you away, but stay firm and upright and wait for the sun which will shine suddenly and infinitely' (A. Bovi, 'Tempo dell' alienazione e Crisi dell' uomo'. Texts by Proust, Kafka, Klee and Musil in Civiltà delle Macchine, July–August, Rome 1966). This love for purity, for the inner truth in the fascinating beauty of perceiving, knowing and creating 'the form which is merely the external expression of an internal content' is decisive in Kandinsky's Concerning the Spiritual in Art; this book is certainly, as Palma Bucarelli (Kandinsky, introductory essay to the catalogue for the Klee Exhibition, National Gallery of Modern Art, Rome, 1970) has stated, 'one of the basic texts of modern art, whose concepts are still relevant today and to some extent always will be, not only for its specific theories on art but primarily because it is a great document of faith in the values of the spirit against every kind of materialism. One may truly say that the extraordinary element in Kandinsky is the extraordinary union of things which seem contradictory and which on the other hand meet in a wonderful balance; intuition and reasoning, impulsiveness and restraint, instinct and intelligence, freshness of feeling and the culture, and particularly, the sincerity which is revealed in his writings where finally there is a great serenity'.

25 *Points*
1934
Galleria del Naviglio,
Milan

The problem of forms

The Solomon R. Guggenheim Museum, which was founded in New York in 1937 with the purpose of collecting works of modern art, has 180 of Kandinsky's pictures, the largest collection of his work in the world. The founders of this great Museum had realized that Kafka was one of the greatest creators of contemporary art. An artist moreover who creates abstract art is indeed filled with love of nature, colour and light. In the training of his youth there is the recollection of the golden cupolas which light up in the sky of Moscow at sunset; here the reds, greens, yellows, whites and blues compose a coloured phantasmagoria, like the colours of the Russian villages, and the popular dresses, and the house interiors, the objects which one forgets because only colour, that absolute and pure totality of colour remains. Then there is Venice, which Kandinsky saw for the first time as a child with his mother, the slow flowing of the waters and the skies with their blue sea air filled with light. And there is Kairouan and the Tunisian coast, shining with sensuous and intense luminosities in the spaces of the sky like flights of love. 'Whilst Mondrian derives directly from the formal severity of Cubism, Kandinsky stems from the violence of the Fauves and the exacerbated Expressionism of the Brücke which is its romantic current. And Expressionism is liberation of colour which acquires an expressive meaning and an absolute value for itself' (P. Bucarelli, op. cit.). An absolute value, as Kandinsky, who is both sensual and spiritual, admits in *Klänge* (Piper, Munich, 1930): 'The swelling blue wave rocks within. A red belt

40

26 *Trick riding*
1935, oil and sand on canvas
32 × 39½ in (81 × 100 cm)
Guggenheim Museum,
New York

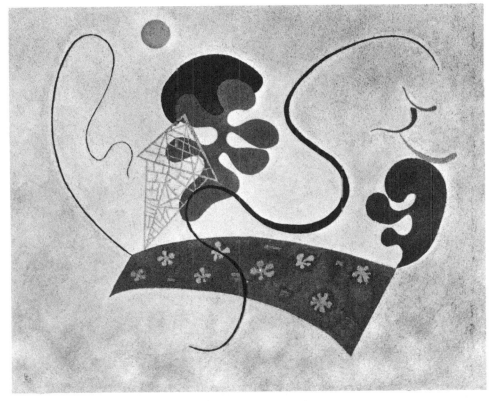

is torn. A red rag. Blue waves . . . the blue waves are deeper. Here is the red which is sinking. A Blue, a Blue was rising, rising in the silence. Thin, pointed, it was whistling, deep it was pricking without piercing . . . White leap, behind white leap. And after this white leap another white leap'. And then a profoundly intelligent statement which is sensitive to the beauty of the universe: 'Form is only the external expression of an internal content. In art, as in nature, the wealth of forms is limitless' (Kandinsky, 'The Problem of forms' in *Il Cavaliere Azzurro,* De Donato, Bari, 1967).

Kandinsky stated clearly that 'even in principle, the fact that an artist uses an abstract form or a real form has no importance. The two forms are internally equal. The choice must be left to the artist who knows better than anyone the most appropriate method of giving substance limpidly to the content of his art. Speaking in abstract terms: in principle, there is no problem of form. And in fact if there were a basic problem of form, a solution should also be possible. Therefore if one knew the solution one would be in a position to create works of art. But if this were the case, art would no longer exist. Speaking in practical terms, the interrogative in the form is modified in the question: what form must I use in this particular case to express my inner experience adequately? The reply is always scientifically accurate and definitive only as far as it concerns each particular case, whilst it is relative in as far as it concerns the others. One form may in fact be the best in one case and the worst in another; everything depends on inner necessity, the only necessity which can make form legitimate. One form can have meaning for more people only when inner necessity selects from similar forms under the pressure of temporal and spatial conditioning. All this however does not modify the relative meaning of the form itself since even the correct form in this particular case may be the wrong one in many others'.

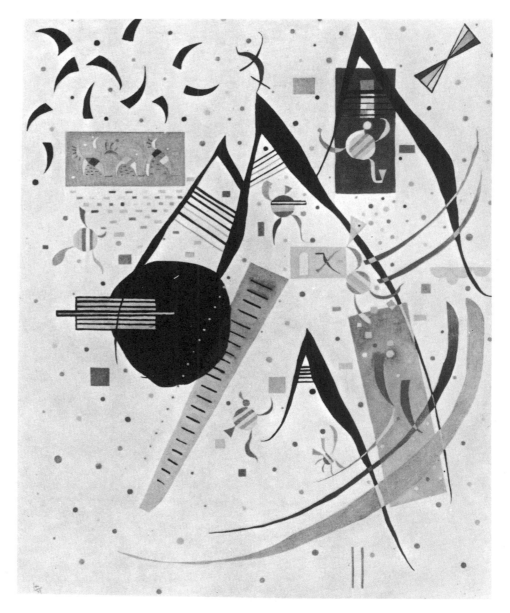

Kandinsky writes extremely clearly and intelligently in this passage, and continues: 'The rules that have been discovered in the art of the past and those that will be discovered in the future (art historians attach an exaggerated value to them) are not universal, but lead to art. If I know the rules of carpentry, I shall always be able to make a table. But those who know the supposed rules of painting cannot be sure of creating a work of art. These rules which presumably can soon lead in painting to a firm and permanent basis are merely acquaintance with the inner effect of individual means and their combination. There will never be rules capable of suggesting the application of formal effects and the combination of means required for a particular case. The practical result is that one must never believe a theoretician (art historian, critic, etc.) when he claims to have discovered this or that objective error in a work of art. Even more: the only thing a theoretician may legitimately state is that he has not yet met this or that application of the means. And again: theoreticians who praise or denigrate a work on the basis of an analysis of forms that already exist are extremely harmful obscurantists because they erect a wall between the work and the naive observer. In this respect (which is unfortunately usually the only possible one) art criticism is art's worst enemy. The ideal art critic is therefore not the man who goes looking for "errors" (e.g. anatomical errors, drawing errors and such like, or anticipating breaches of the "permanent basis") deviations, examples of ignorance, plagiarism, etc. etc., but whoever attempts to feel the inner action of this or that form and then tries to communicate the whole

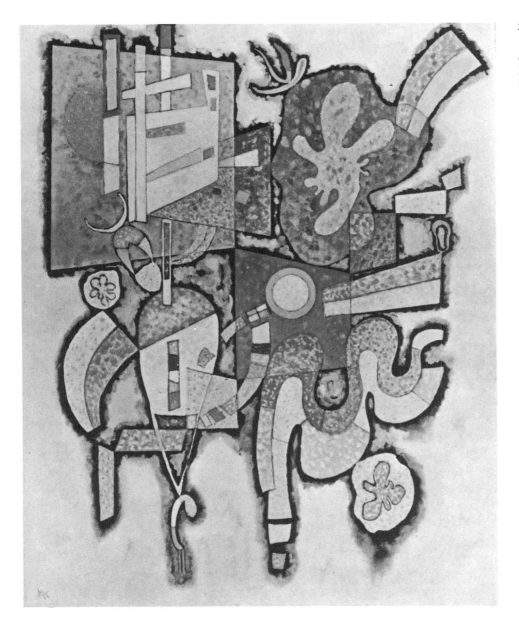

28 *Ambiguity*
1939, oil on canvas
$43\frac{3}{4} \times 32$ in (111×81 cm)
Musée d'Art Moderne,
Paris

of his experience to the public, vigorously and expressively. To do this
the critic should certainly have a poet's soul (in fact the poet must feel
objectivity in order to be able to give subjective substance to his sensations)
and indeed should have a creative faculty. In reality on the other hand critics
are often failed artists who after failing for lack of their own creative power,
feel called upon to control that of others. The problem of forms is often
harmful to art just because men of small talent (i.e. men who are not moved
by an inner vocation for art) use unusual forms, create illusory works and
provoke confusion.'

In our opinion, these reflections of Kandinsky's are extremely relevant
today. He certainly does not undervalue the philological and critical method
of the historian and the scholar but he puts it in its proper context. The fact
is that the crisis which already existed at the time of 'formalism' and 'aestheti-
cism' cannot be overcome by semantics about technique. For such semantics
are dangerously illusory and fictitious, particularly as regards technique,
which is the necessary means of a language which is inherent in the inner
creative consciousness of the artist. Kandinsky noted the same kind of
danger, suspecting that art was going to be 'programmed' by bureaucratic
methods, as indeed did Malevič when he stated in the catalogue for the
Tenth State Exhibition of Abstract Creation and Suprematism in Moscow:
'Every art with a utilitarian aim is worthless; art without large dimensions
is merely applied art relating to the present, which it is conscious of; it is

Kandinsky and Pollock

43

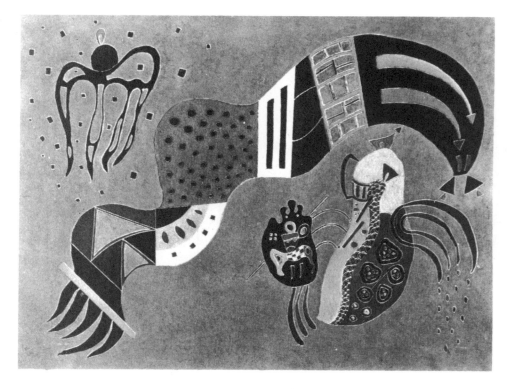

29 *Moderate impulse*
1944, oil on board
$22\frac{3}{4} \times 16\frac{1}{2}$ in (58 × 42 cm)
Musée d'Art Moderne,
Paris

merely the conclusion of a philosophical thought which comes back to our field of vision to please a passing taste and create a new one.'

Kandinsky struggles throughout his life, in his writings and his painting, not only to get rid of everything conventional, academic, worn out and banal (and he succeeded splendidly when he created his inner life), but also to communicate to others these new proofs and new perceptions of the spirit and therefore of the reality of the universe perceived by the spirit; these perceptions and reality cannot be reduced to little formulae as is so common nowadays when there are so many incompetent young upstarts who advocate technology and making man into a tool. He would have been horrified by these things and stated it many times in his writings: science and technology must be taken seriously and they require much talent. They require an authentic courage and an inner necessity which not all men have. Therefore he was averse to every idea of making a tool of men, as much as to the false spiritual 'mirages' against which Bergson's scathing irony was directed when he started to reassess man's instinct, which was the starting point of his 'creative evolution'. In our century another artist struggled with impressive creative force against the idea of man as a tool and man's reduction to the state of a productive machine. This was Jackson Pollock. Many drawings (1931–38) in the Lee Krasner Pollock collection in New York show how Pollock studied and appreciated European culture from Michelangelo to Expressionism, in fact to Klee. But 'he intervened in our reality and our history (not only in our imagination), he revealed to us a mode of our being, our existential condition in which we recognize ourselves' (A. Busignani, *Jackson Pollock*, Sansoni, Florence 1970). Pollock shows how America, particularly its younger generation, is living through its epic period of search and anxiety, on a path parallel to that of Europe which has inherited so much from the Weimar Bauhaus. Kandinsky is among its most stimulating masters, precisely because his is not an 'ideal' search. But he used the deep stimulus of science and nature to invite us to ascend from the subconscious to the luminous and illuminating planes of the conscious: consciousness is also the result of a solitude which Kandinsky and Pollock share in a totally different language though they both have links with Expressionism, and each lived in a different historical period. In fact they lived in successive periods of time; but this succession is closely connected by the common danger which threatens man in various degrees, as both artists observed: the alienation of man's inner consciousness.

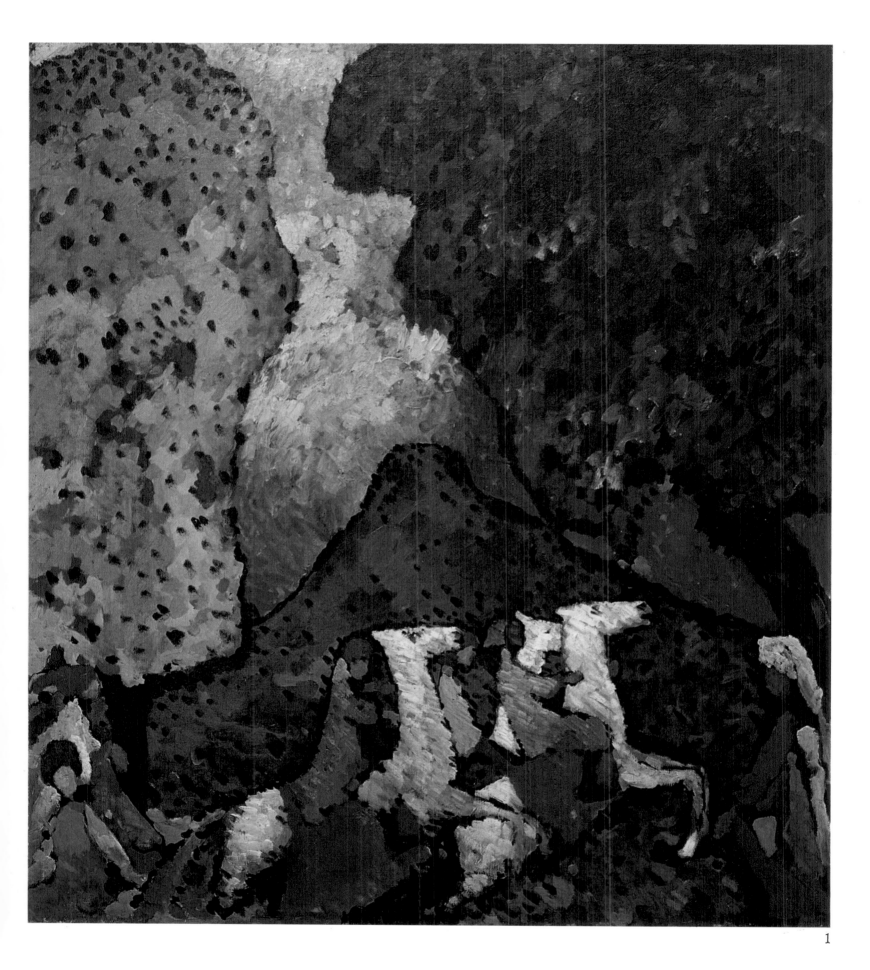

1

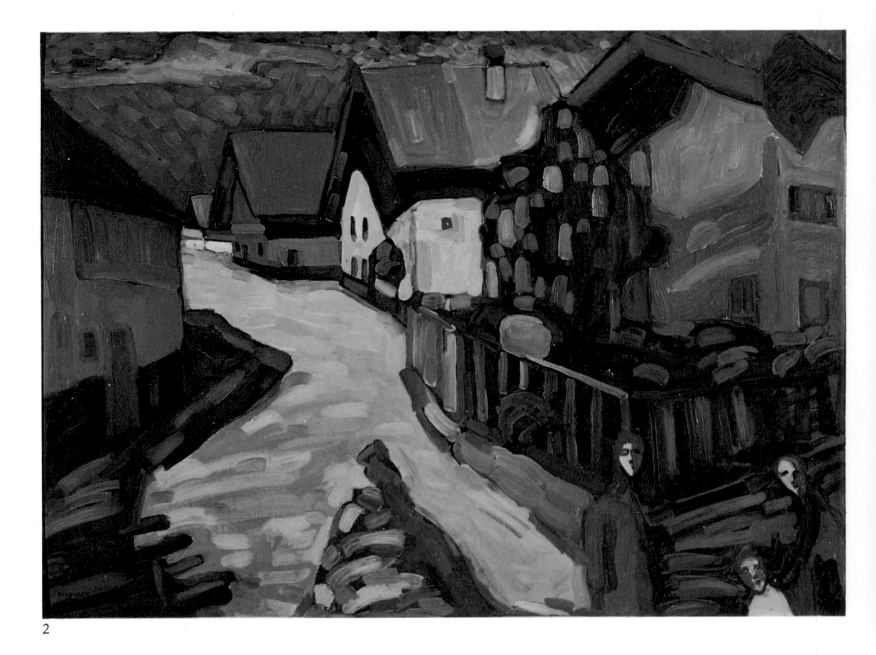

2

3

4

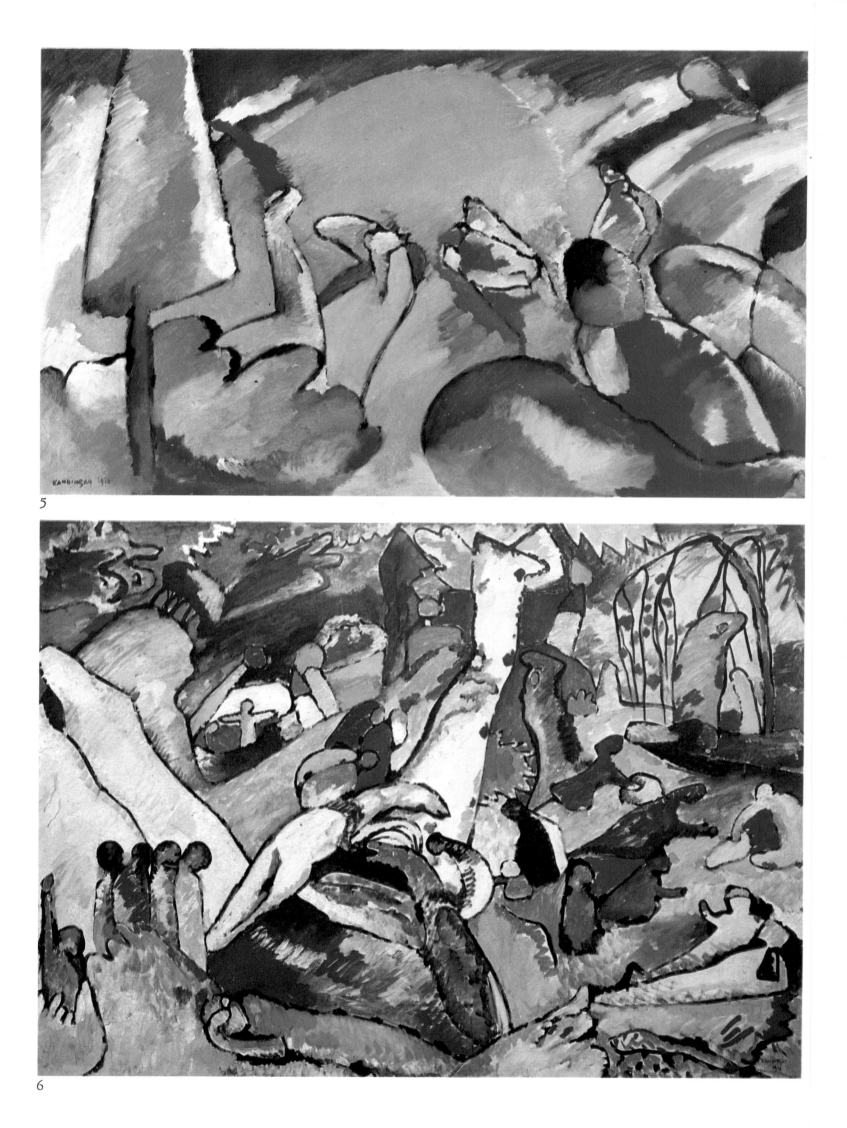

5

6

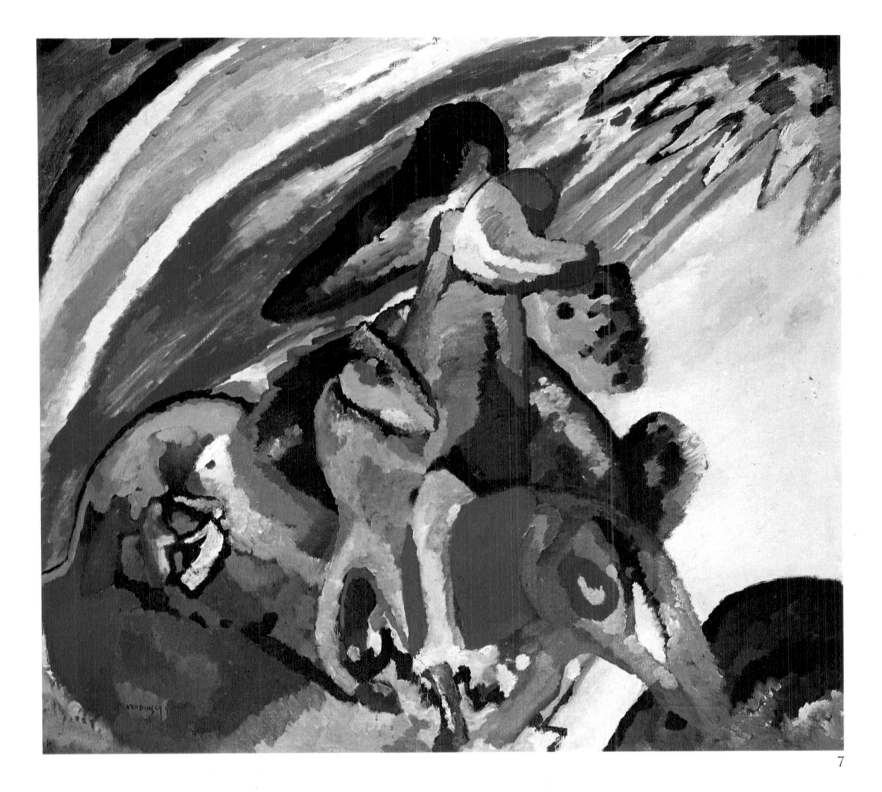

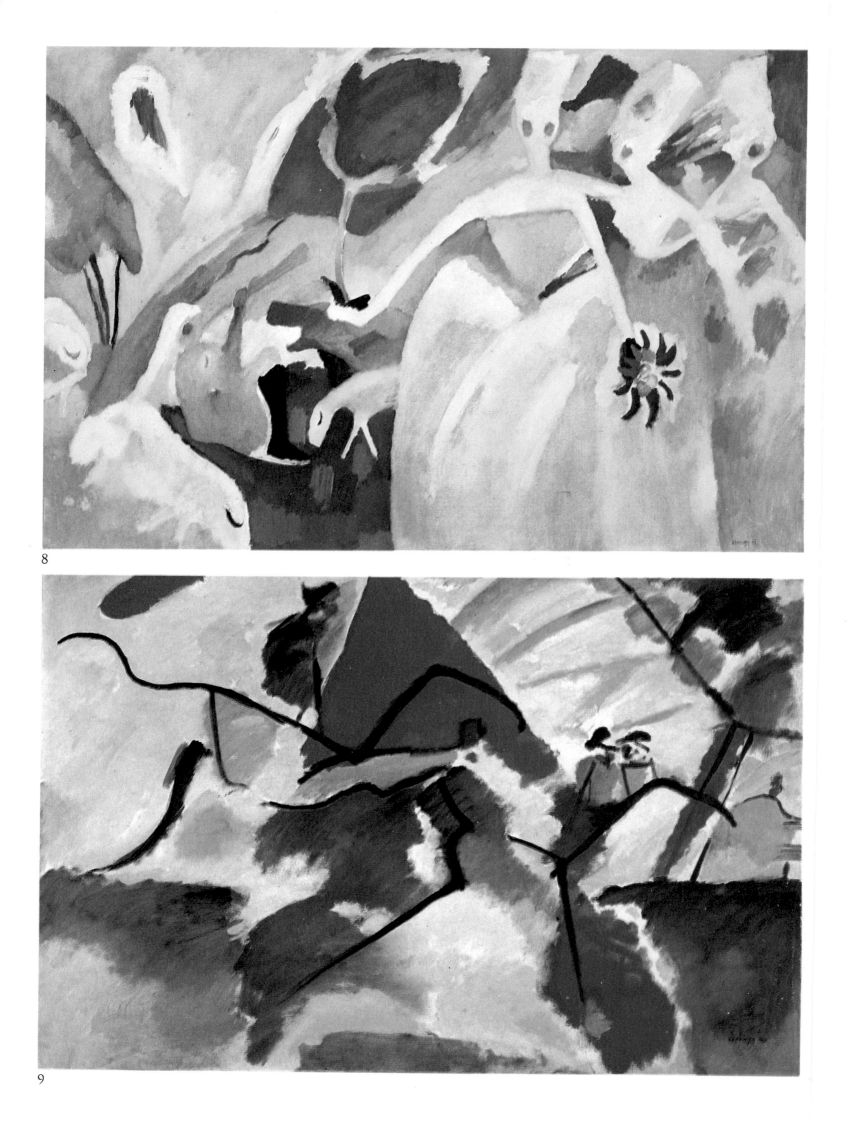

8

9

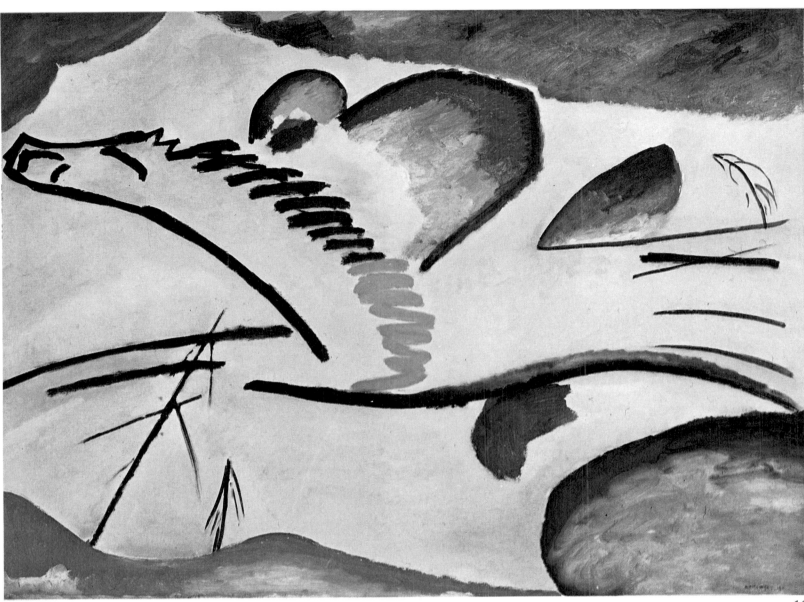

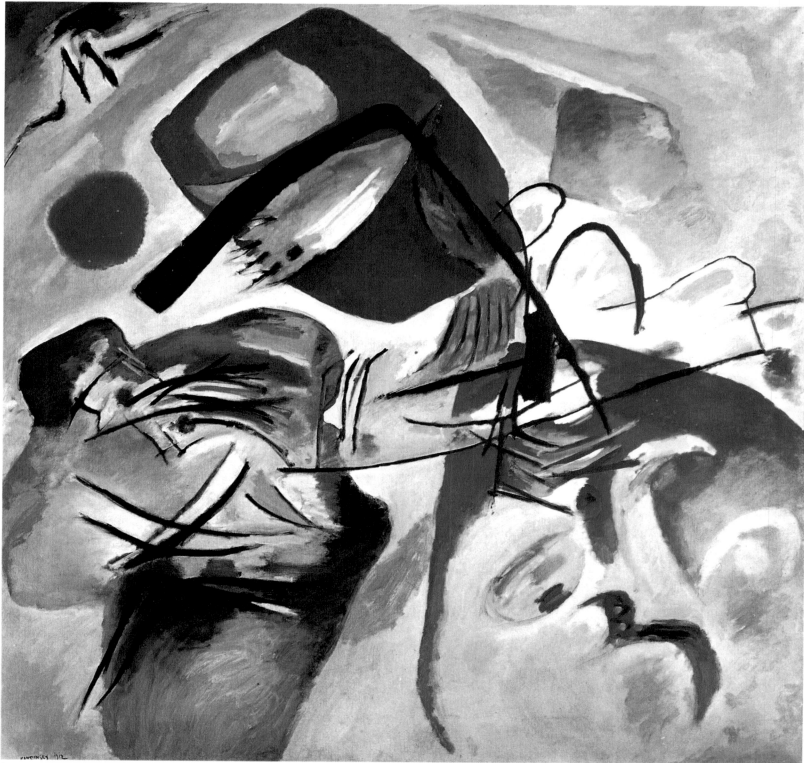

11

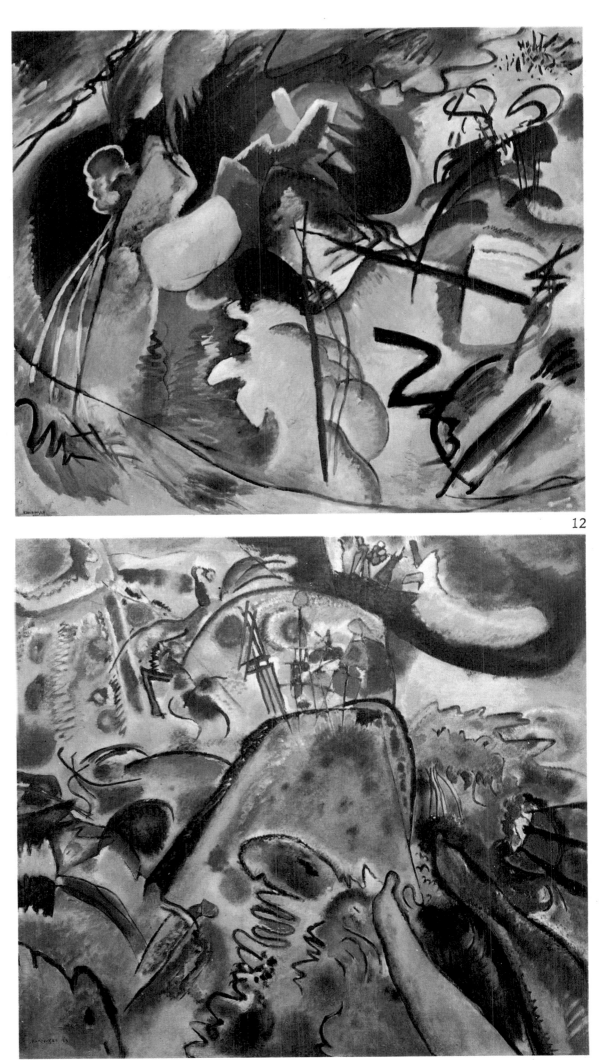

12

13

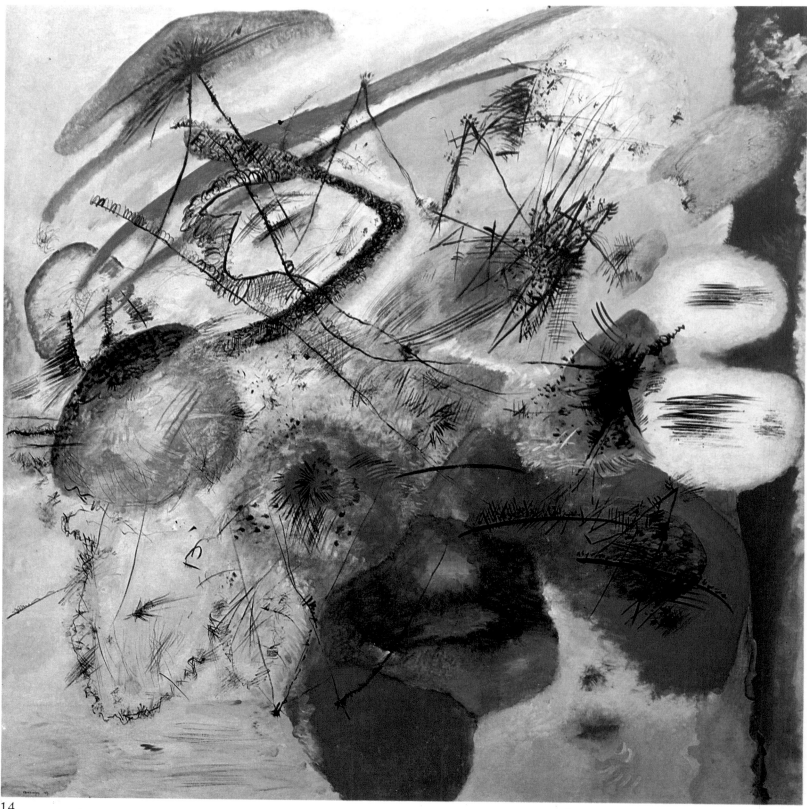

14

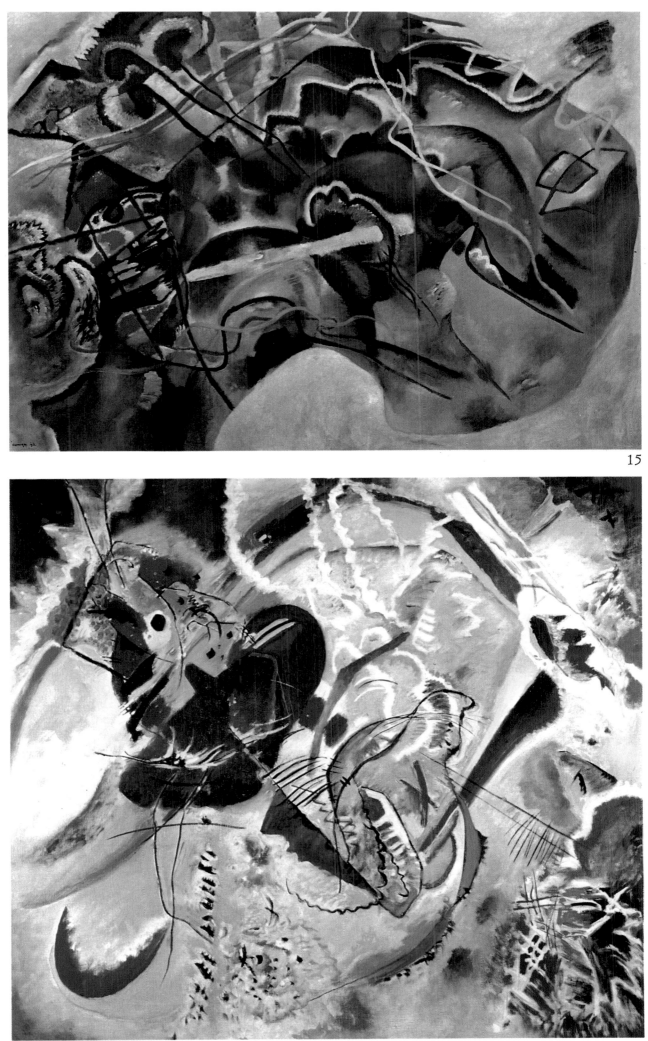

15

16

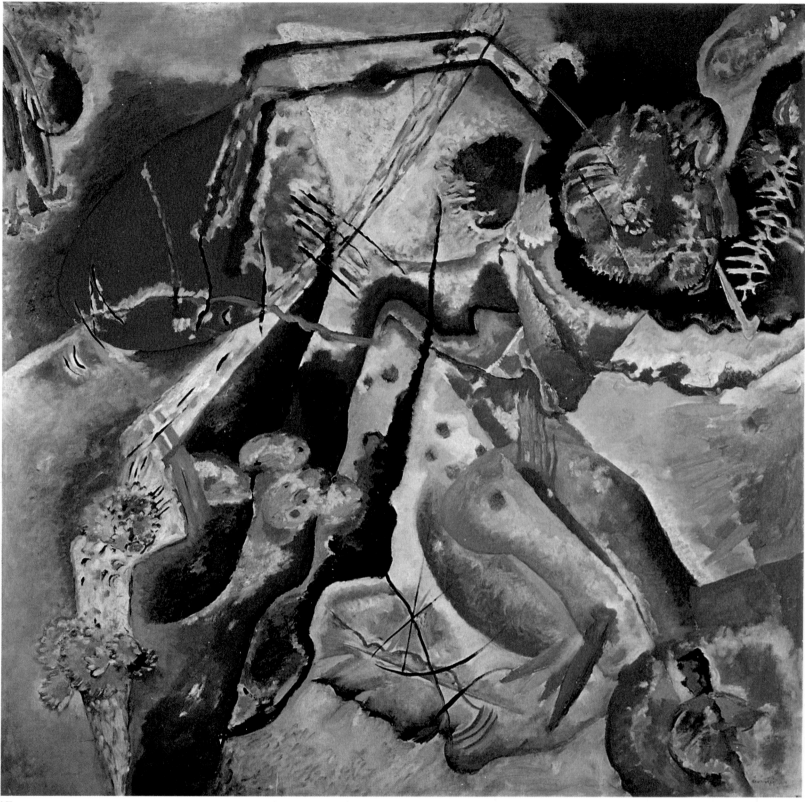

17

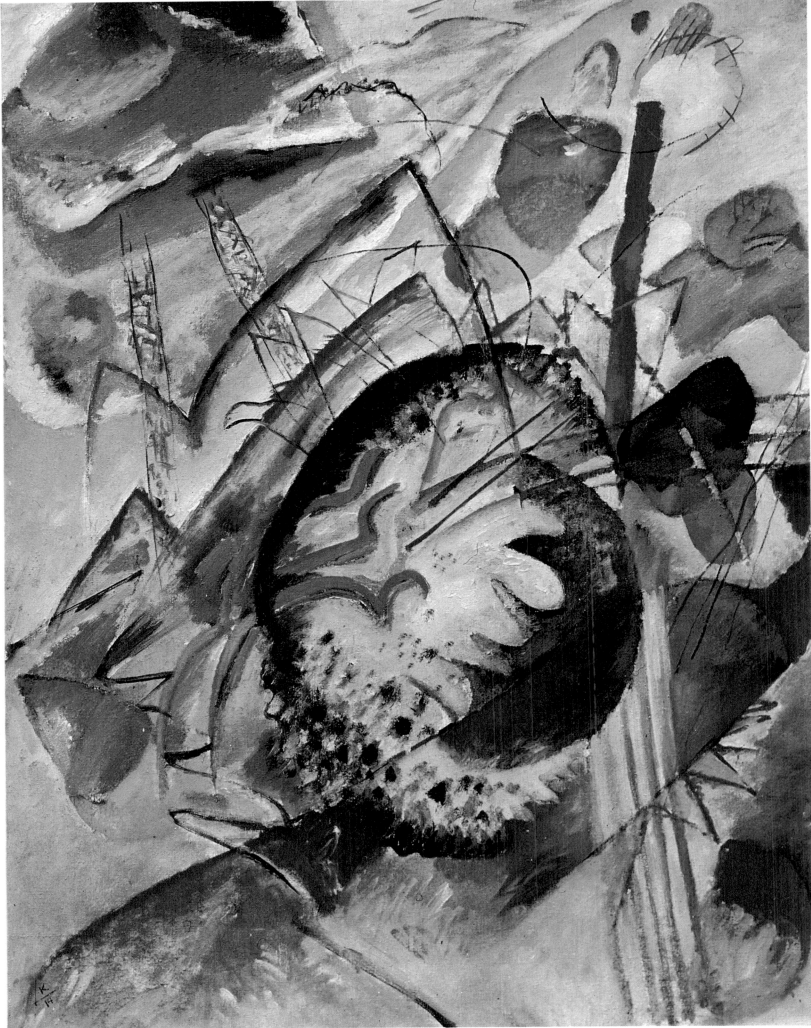

18

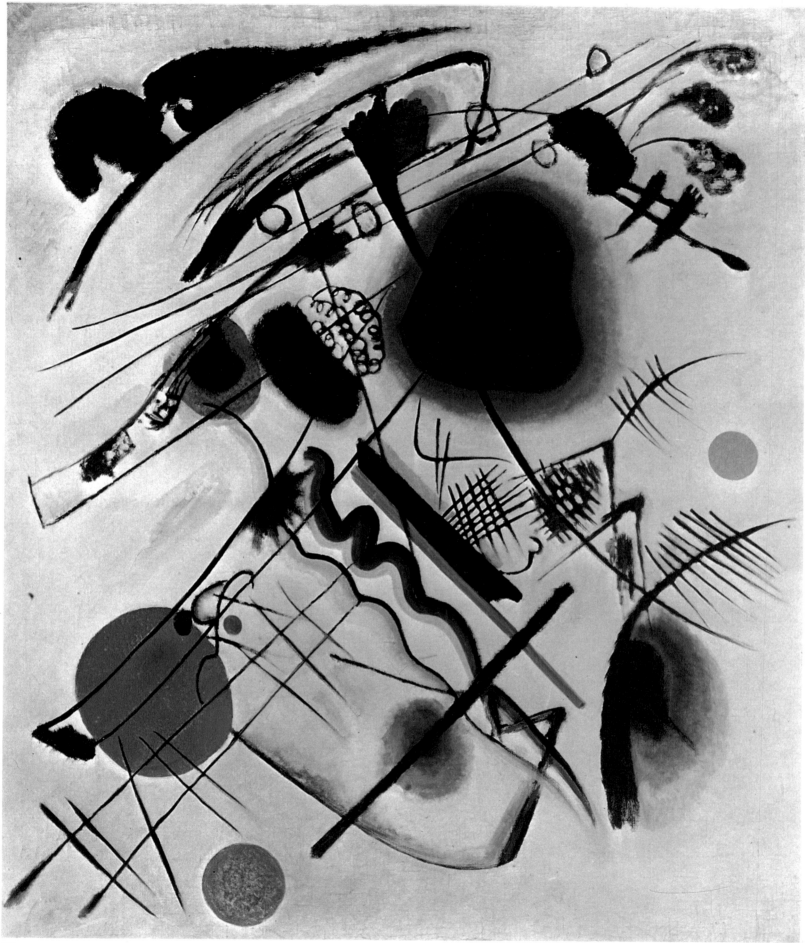

19

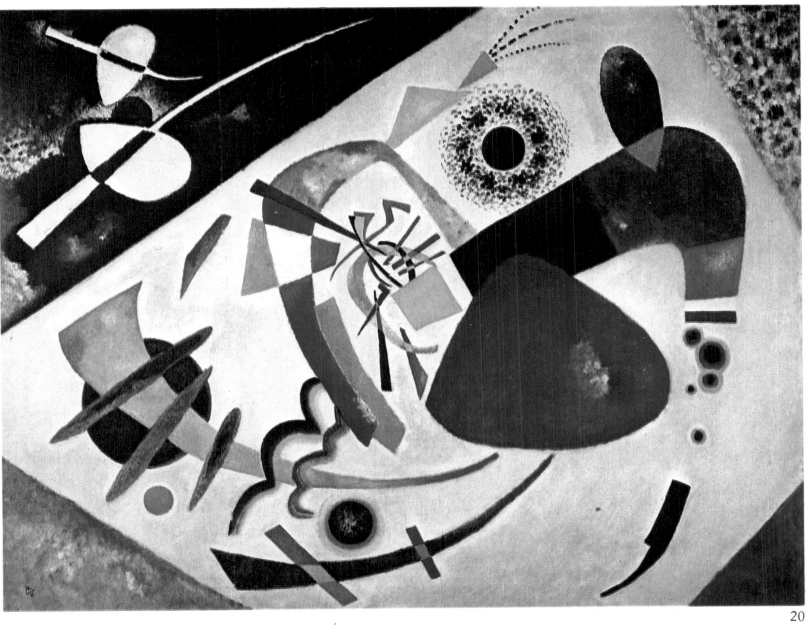

20

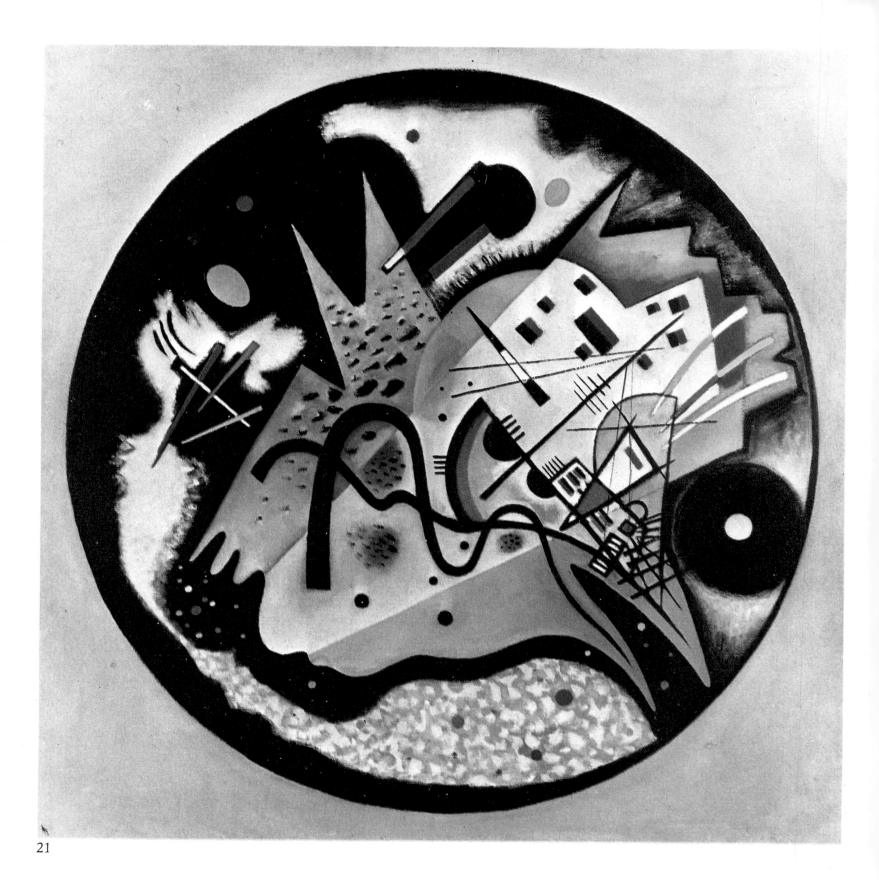

21

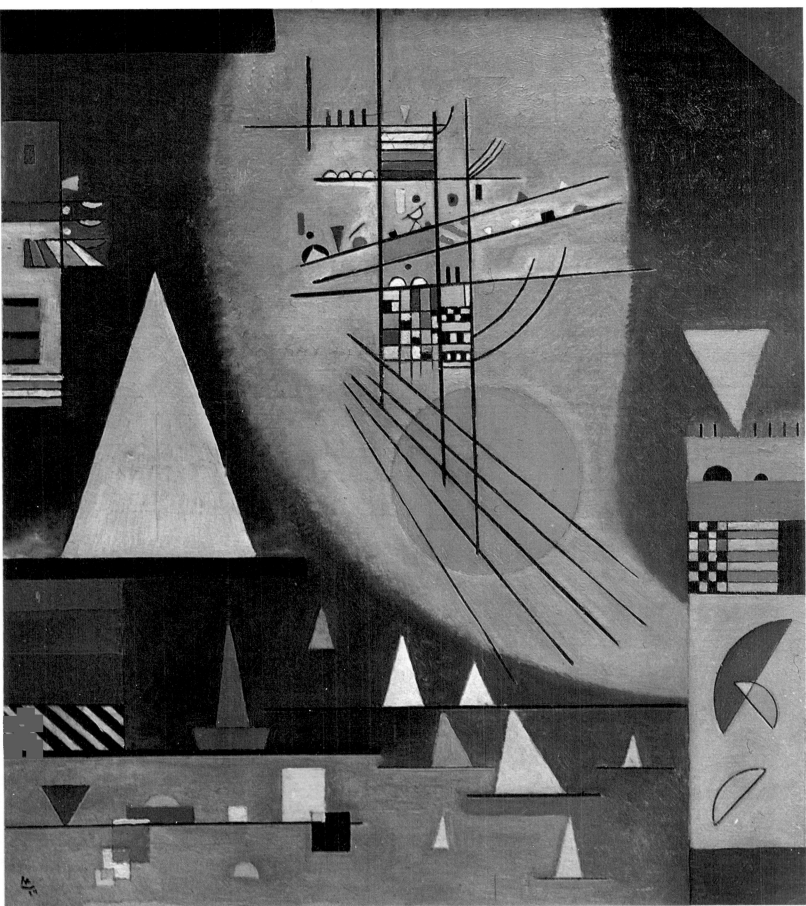

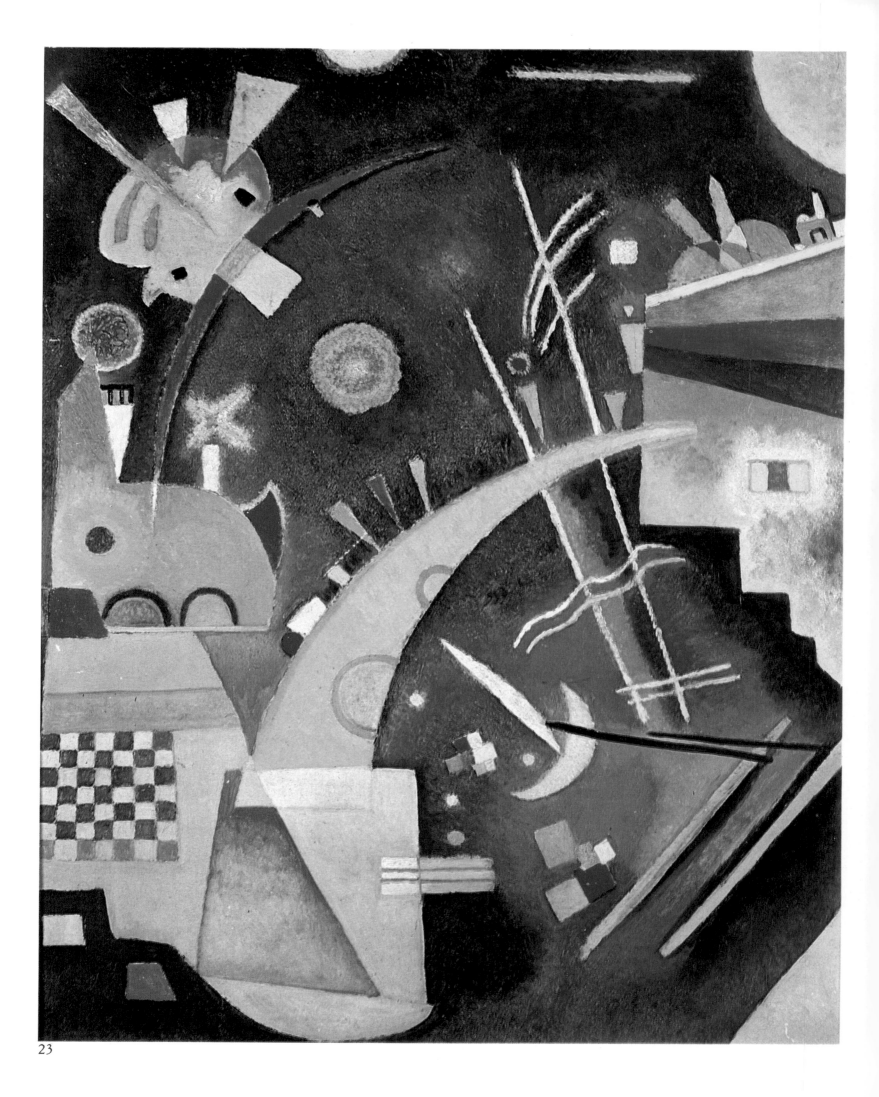

23

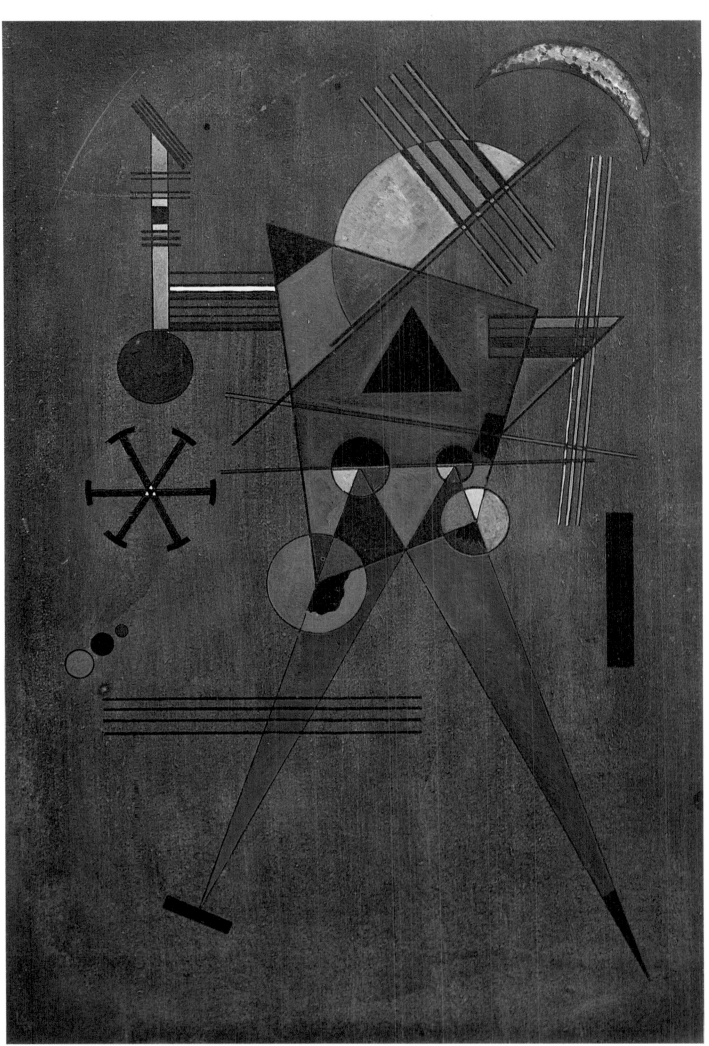

24

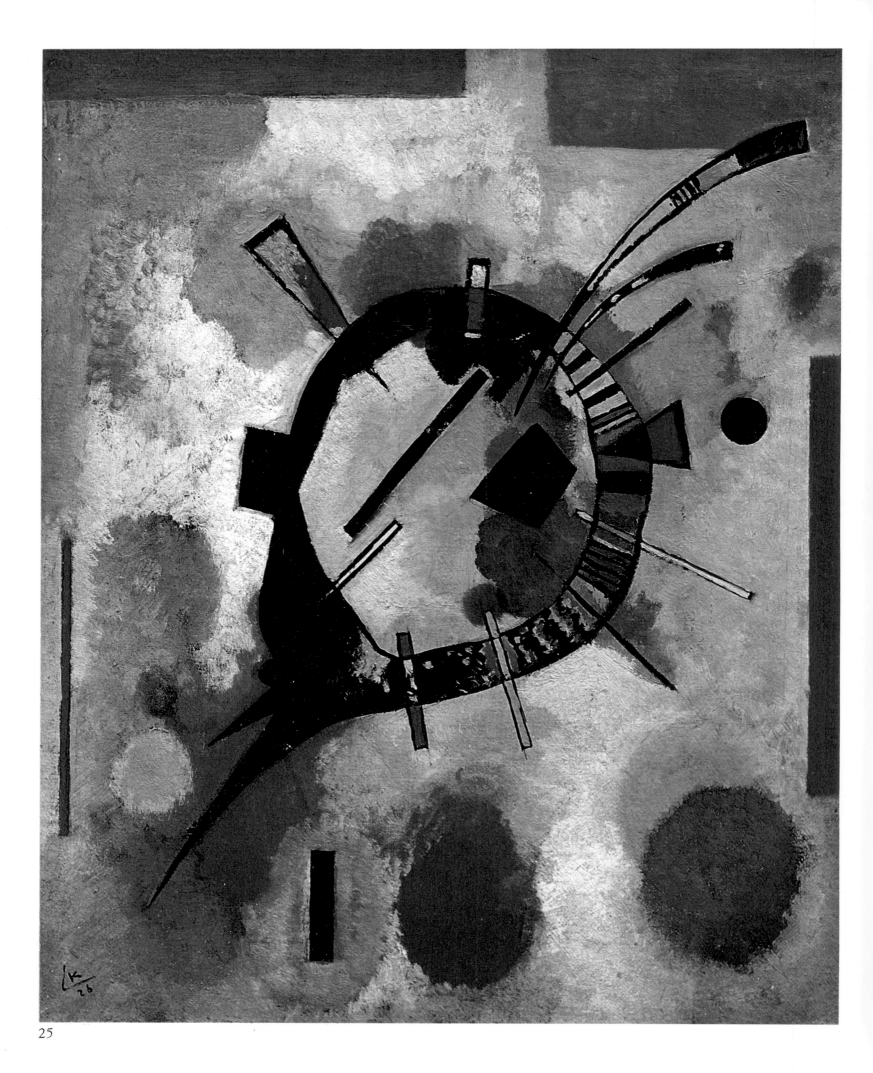

25

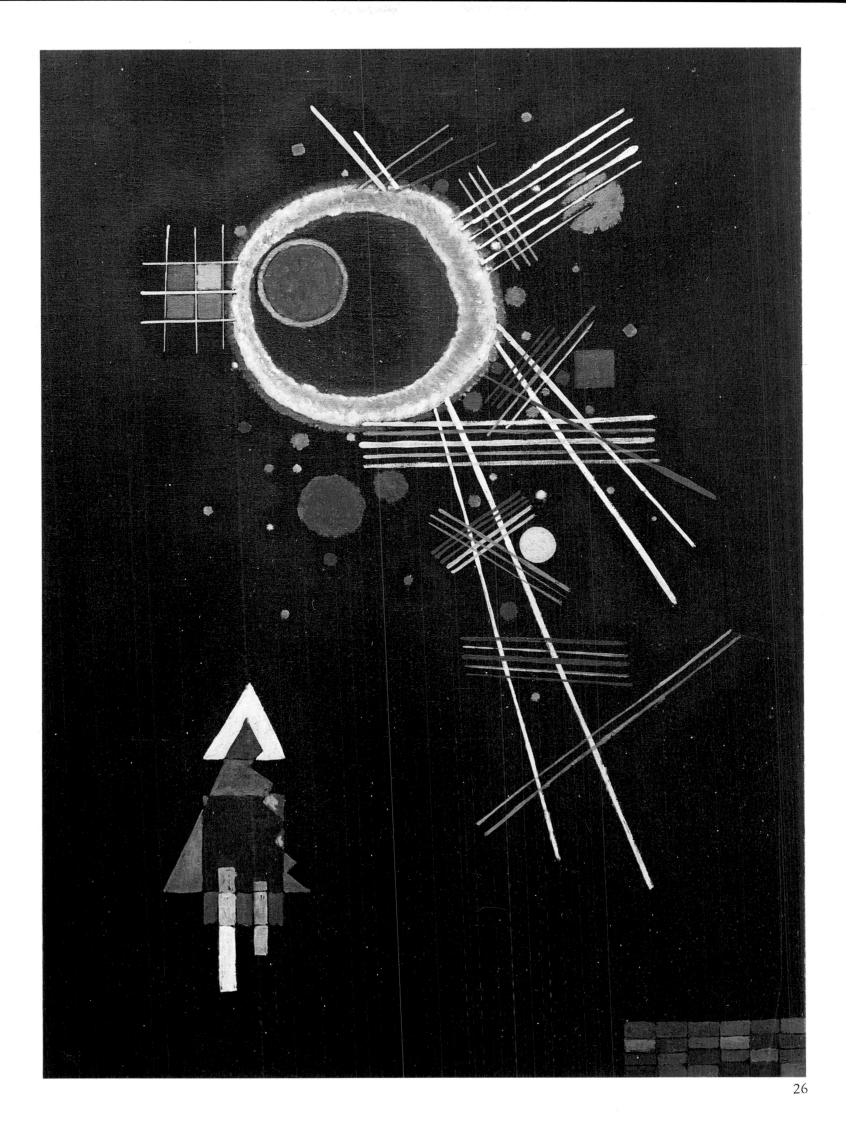

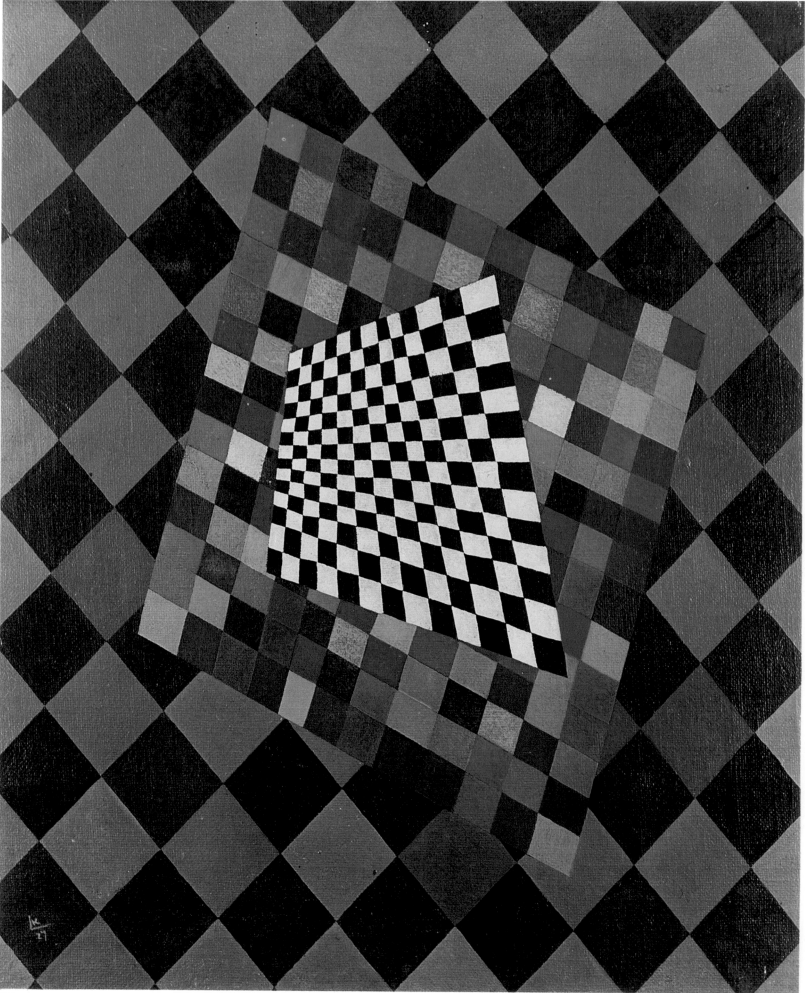

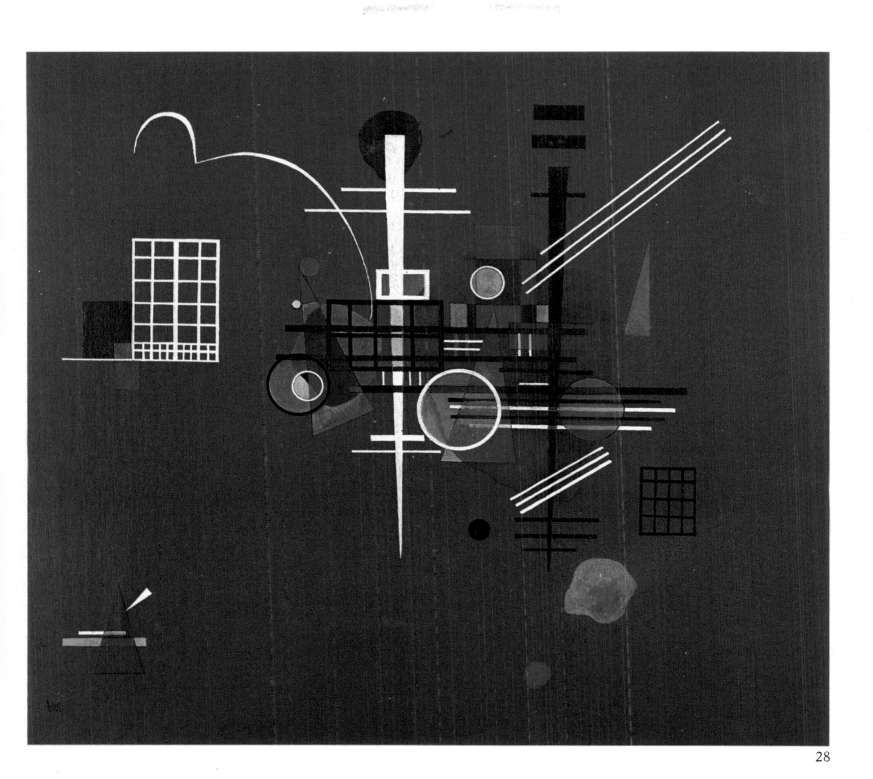

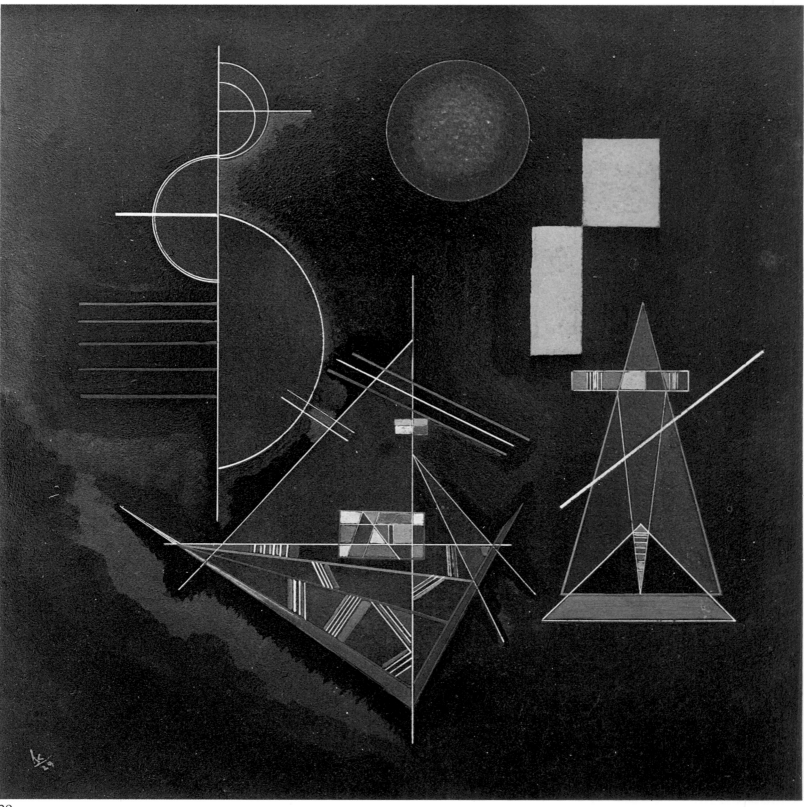

29

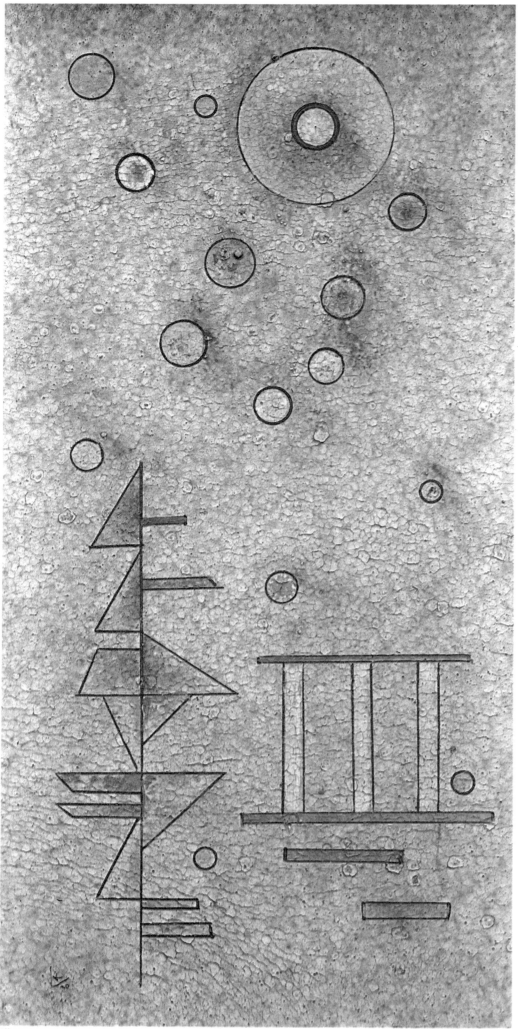

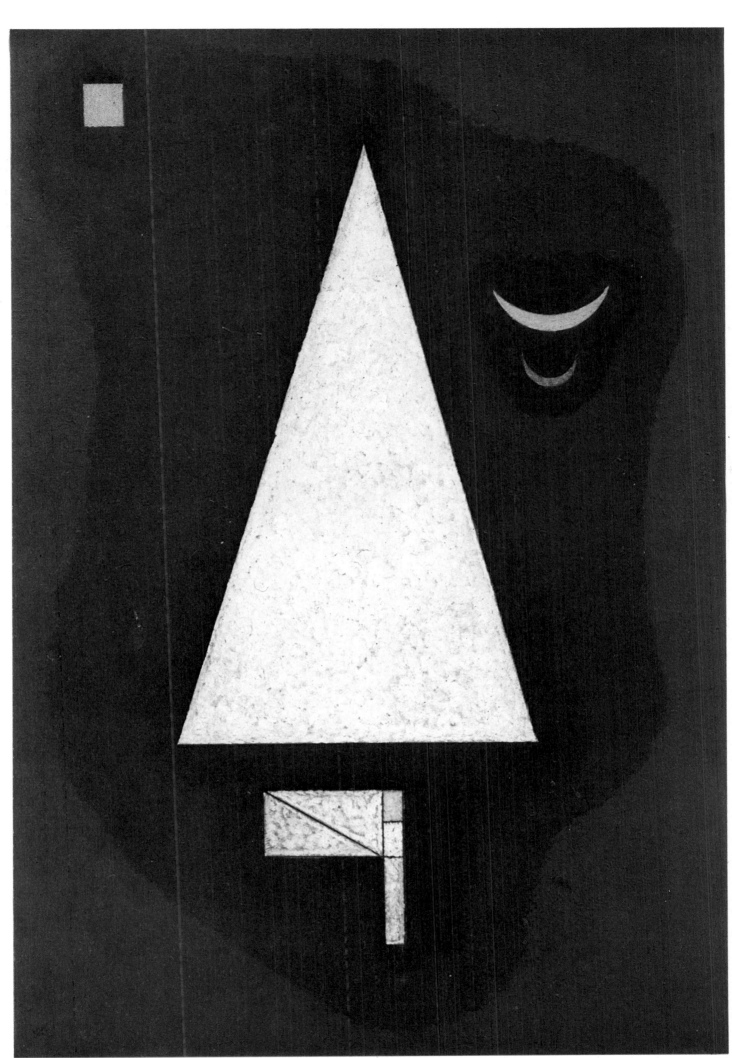

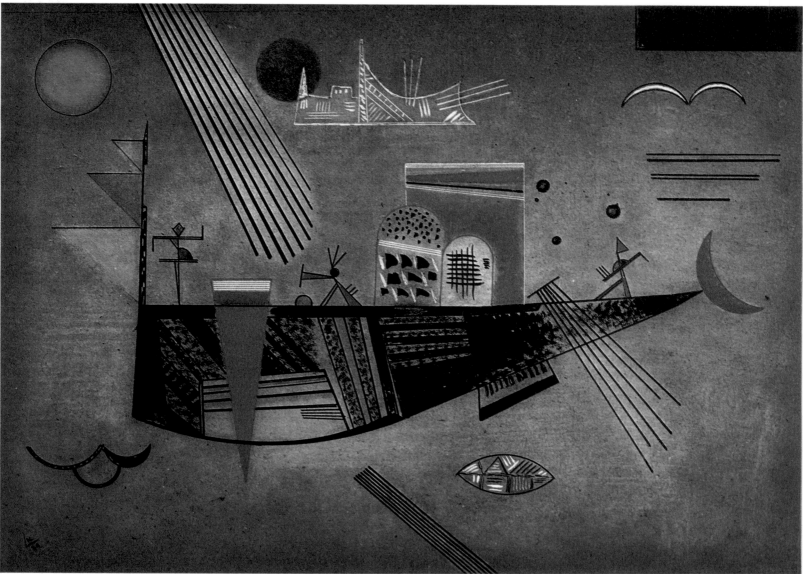

33

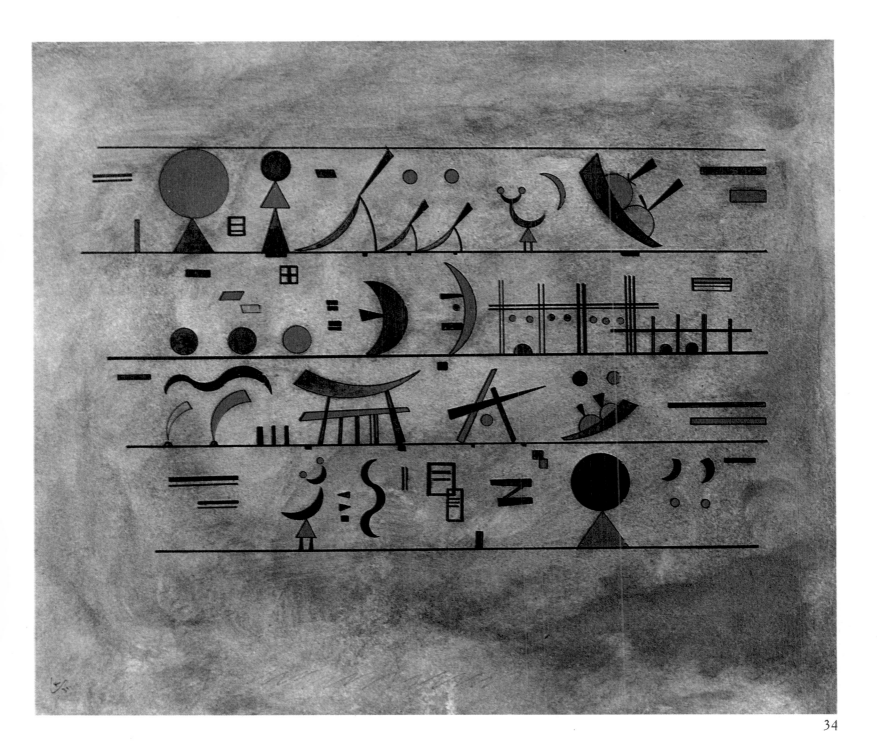

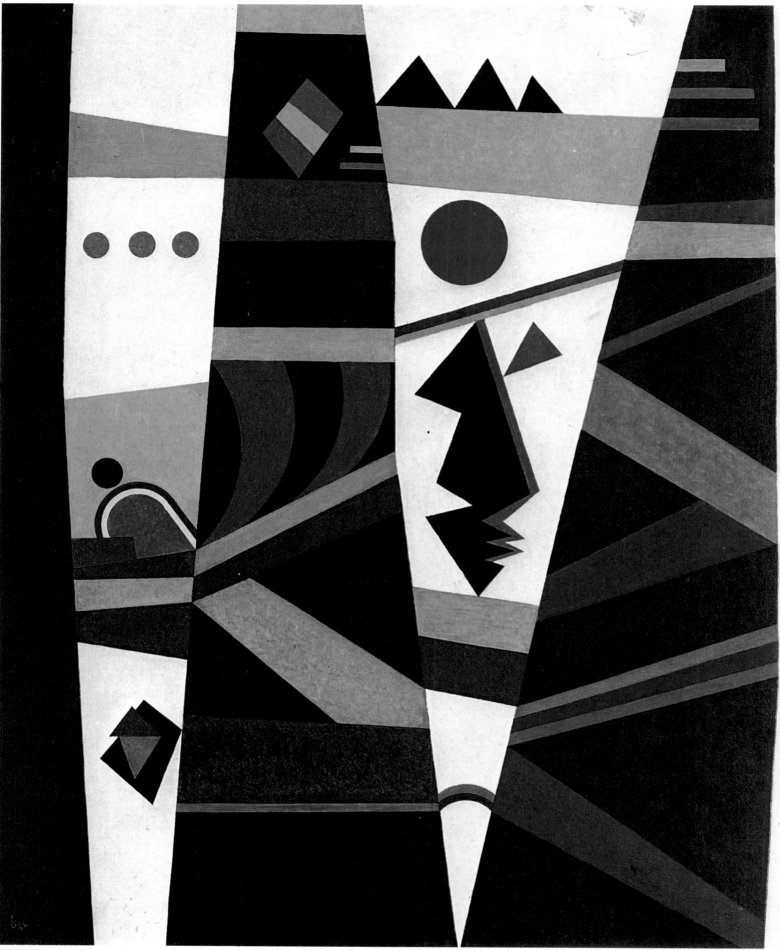

35

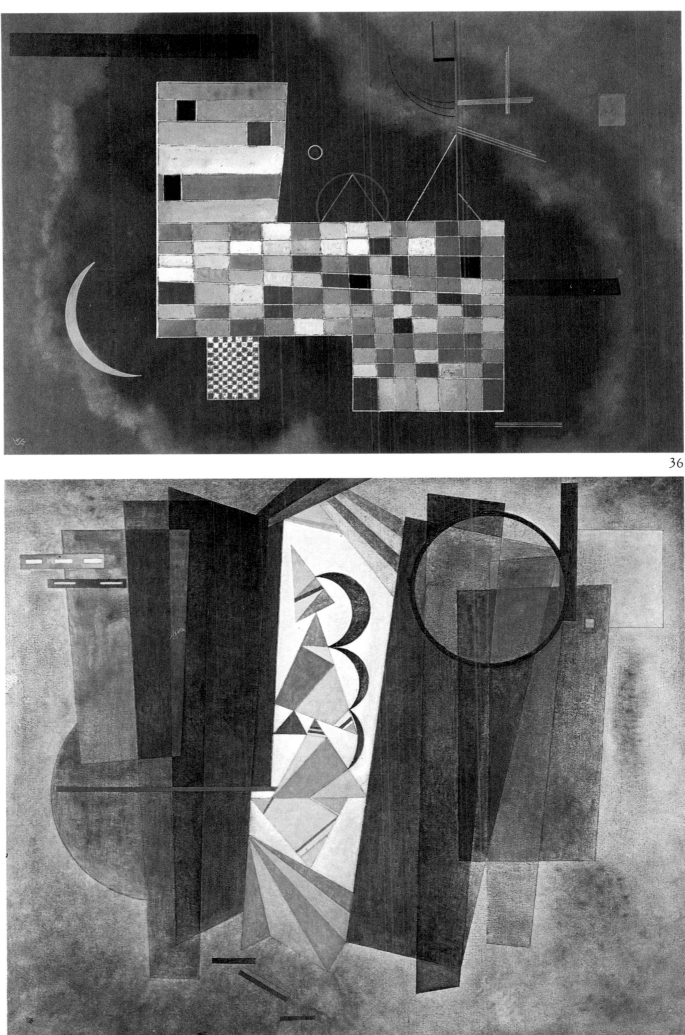

36

37

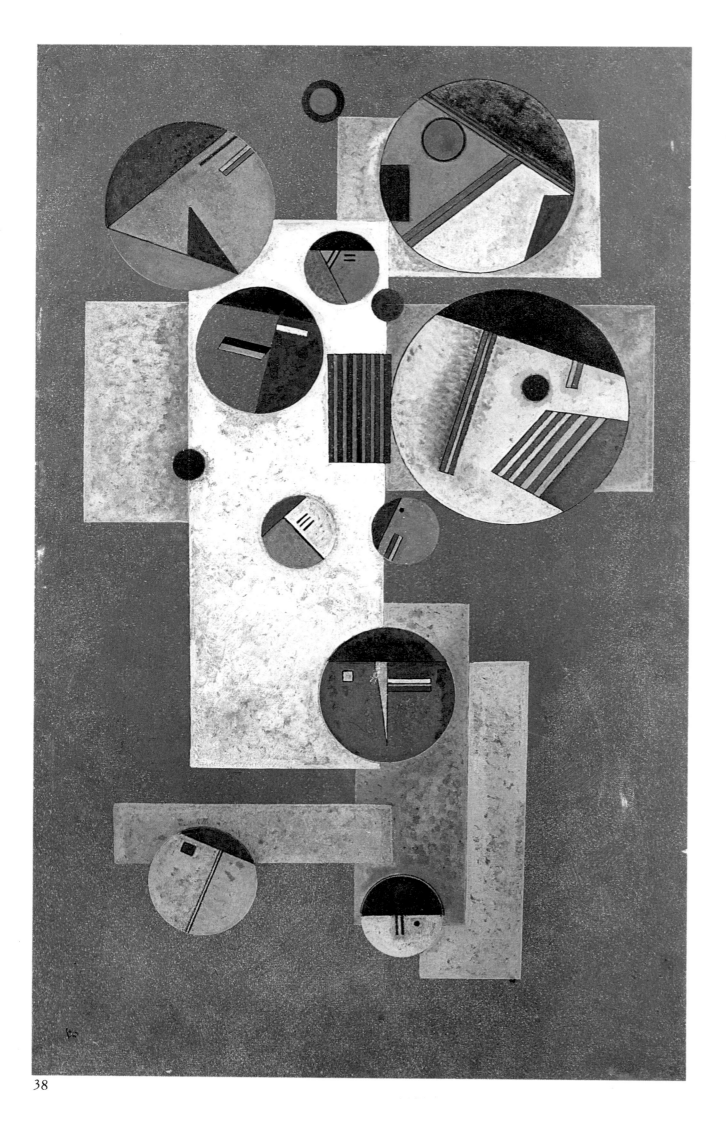

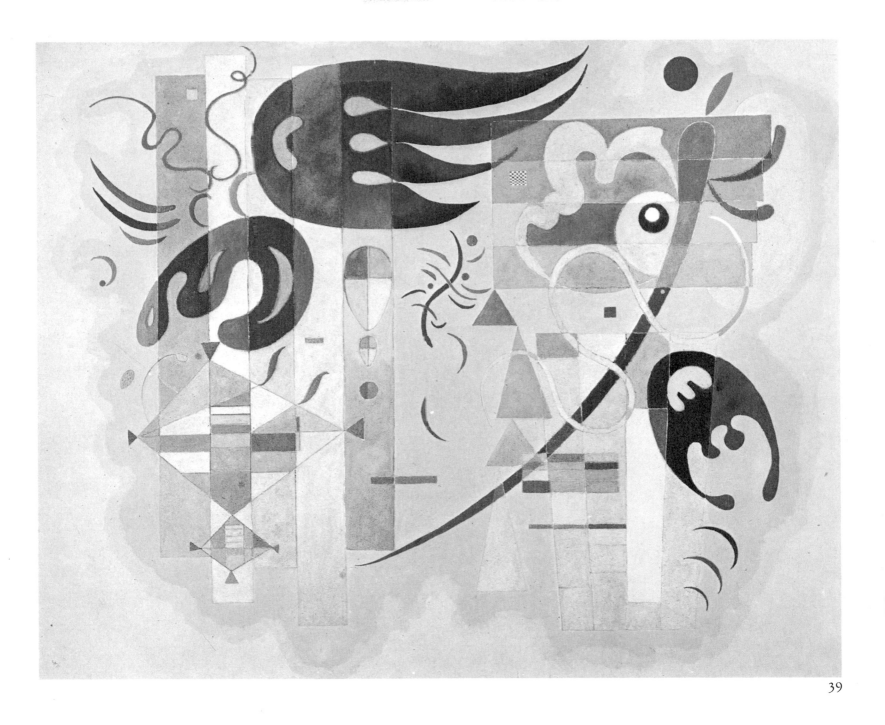

39

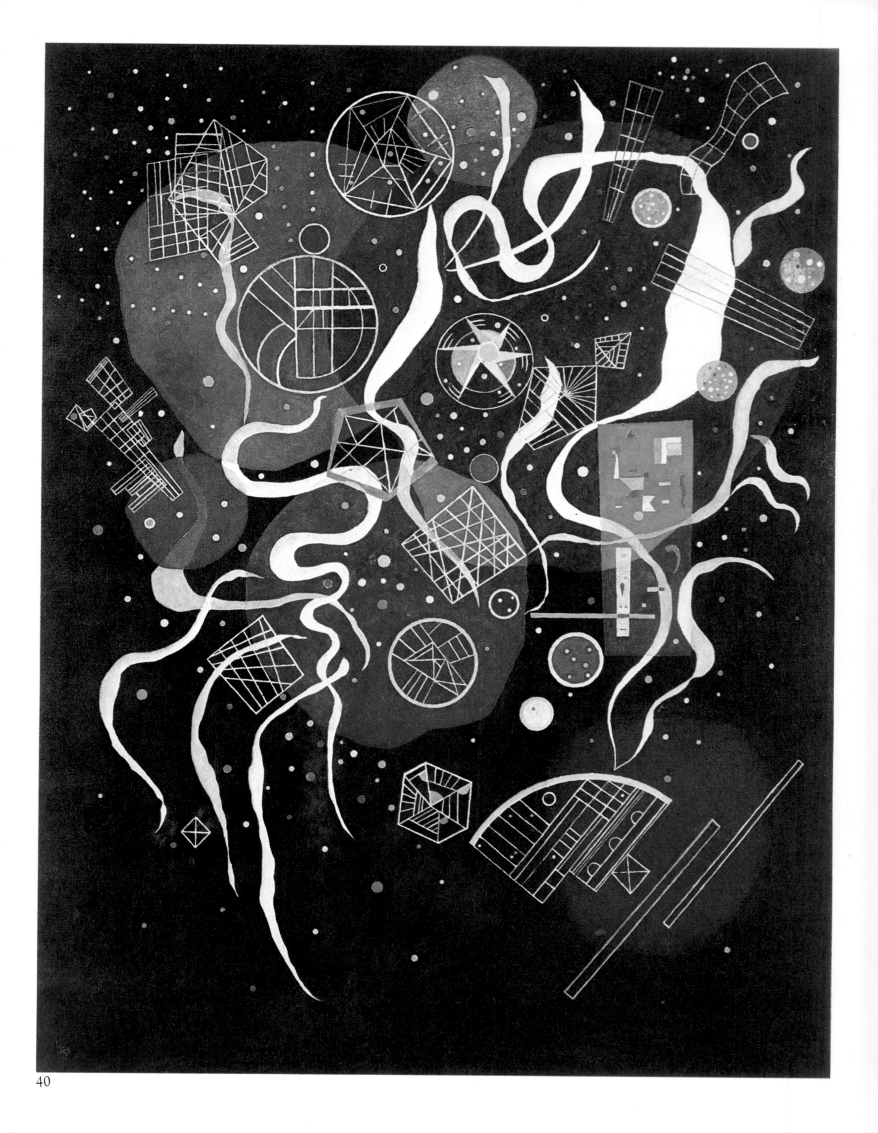

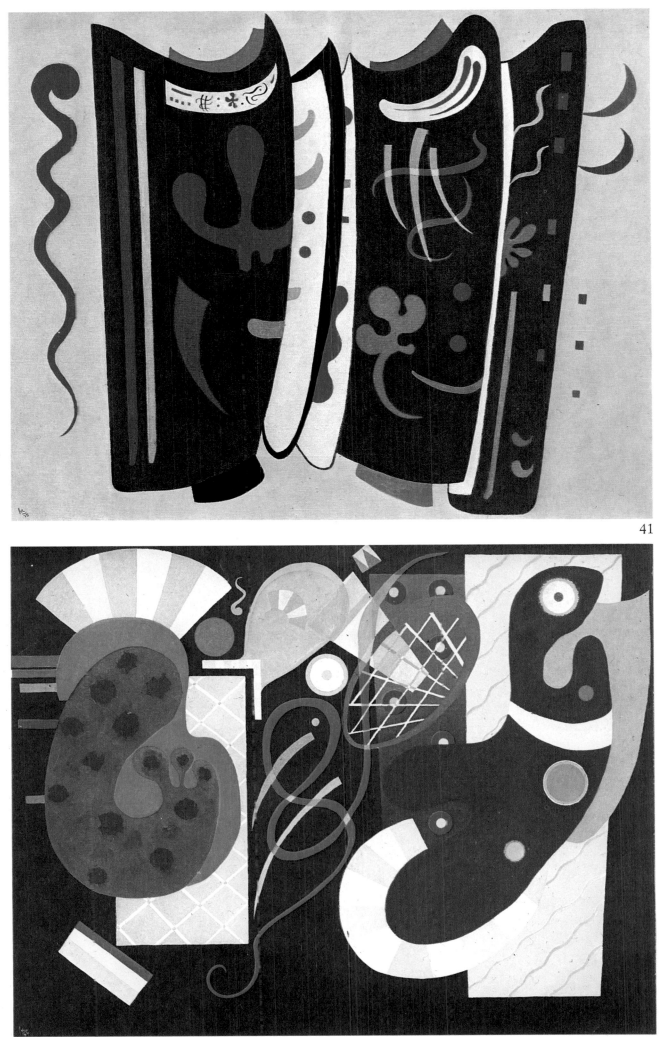

41

42

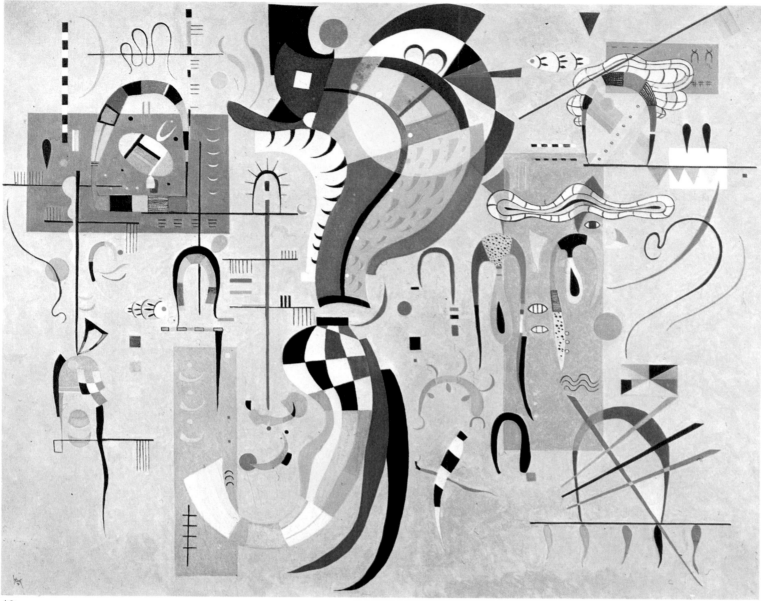

43

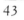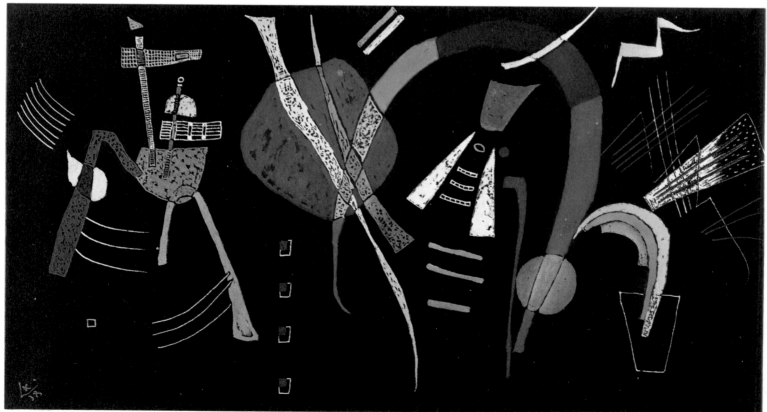

44

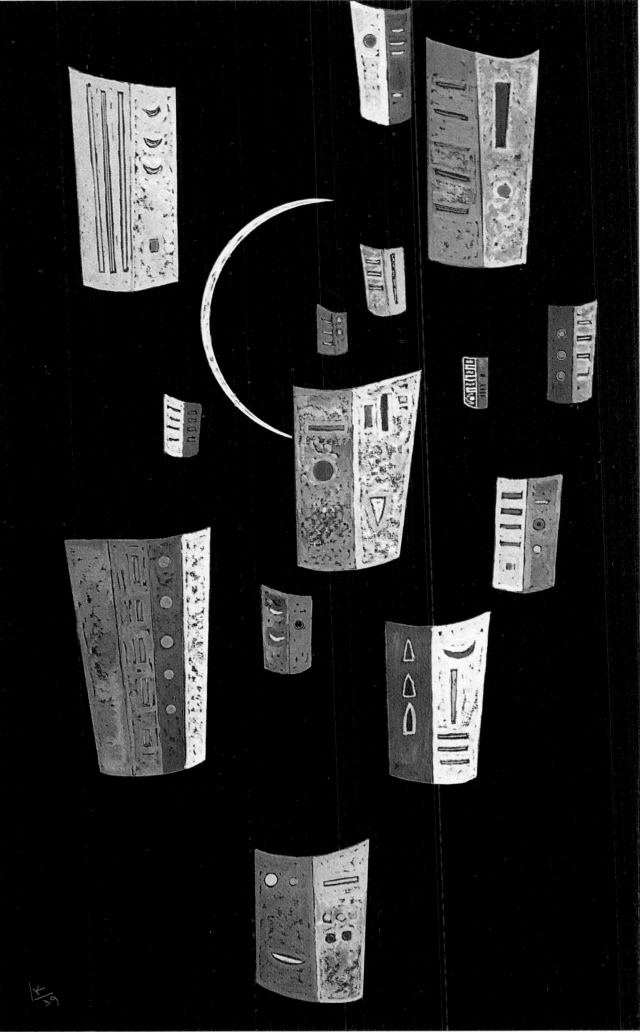

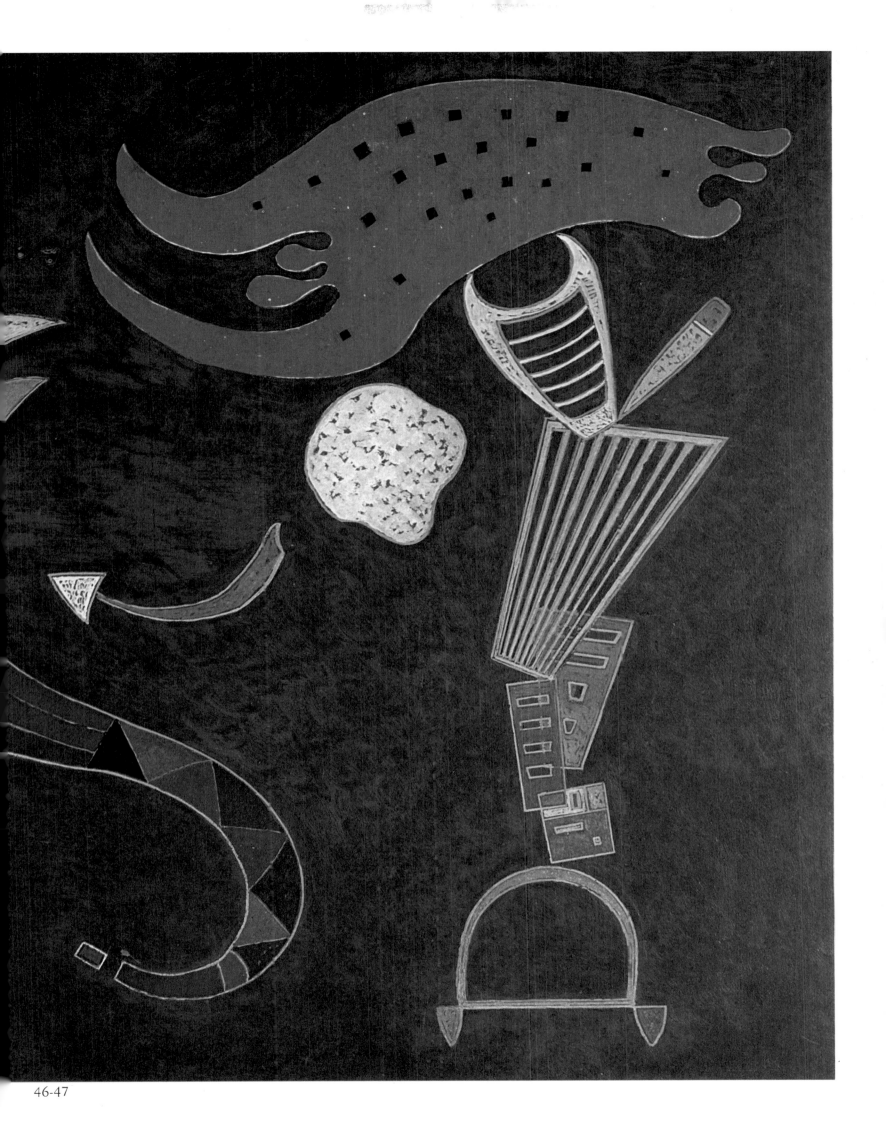

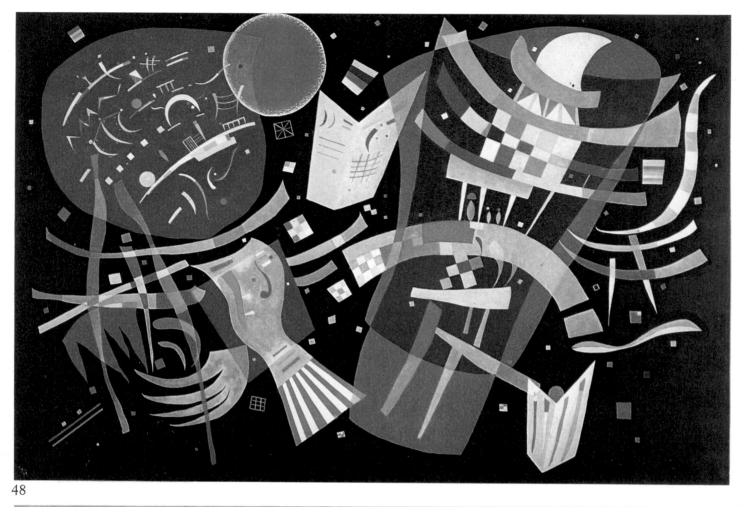

48

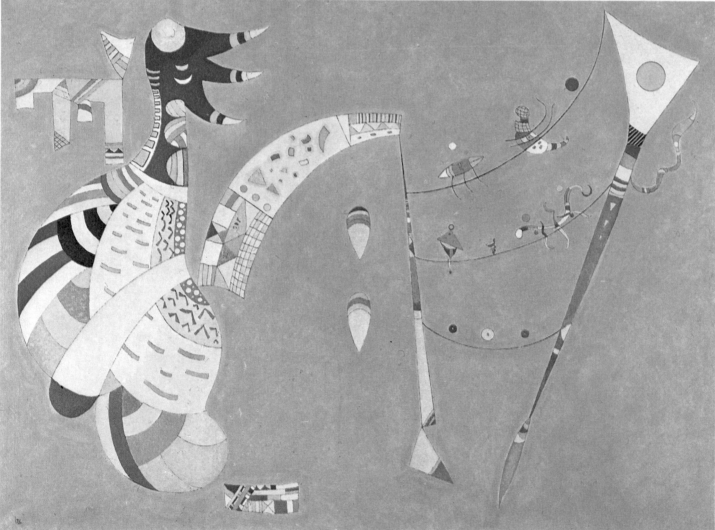

49

Description of colour plates

1 *The blue mountain*
1909, oil on canvas, $41\frac{1}{4} \times 37\frac{3}{4}$ in (105×96 cm)
Guggenheim Museum, New York

2 *Road at Murnau*
1908, oil on canvas, $27\frac{1}{2} \times 37\frac{1}{4}$ in (70×95 cm)
Musée d'Art Moderne, Paris

3 *Countryside with bell tower*
1909, oil on board, $29\frac{3}{4} \times 39\frac{1}{4}$ in (75.5×99.5 cm)
Musée d'Art Moderne, Paris

4 *Improvisation III*
1909, oil on canvas, $37 \times 51\frac{1}{4}$ in (94×130 cm)
Musée d'Art Moderne, Paris

5 *Improvisation XIV*
1910, oil on canvas, $28\frac{3}{4} \times 49\frac{1}{4}$ in (73×125 cm)
Musée d'Art Moderne, Paris

6 *Composition II (study)*
1910, oil on canvas, $50\frac{3}{4} \times 38\frac{1}{4}$ in (129×97 cm)
Guggenheim Museum, New York

7 *Improvisation XII (rider)*
1910, oil on canvas, $38\frac{1}{4} \times 42$ in (97×106.5 cm)
Städtische Galerie, Munich

8 *Pastoral*
1911, oil on canvas, 41×61 in (104×154 cm)
Guggenheim Museum, New York

9 *Improvisation V (park)*
1911, oil on canvas, $41\frac{1}{4} \times 61\frac{3}{4}$ in (105×157 cm)
Musée d'Art Moderne, Paris

10 *Lyric*
1911, oil on canvas, $37 \times 51\frac{1}{4}$ in (94×130 cm)
Boymans van Beuningen Museum, Rotterdam

11 *With the black arch*
1912, oil on canvas, $71 \times 77\frac{1}{4}$ in (180×196 cm)
Musée d'Art Moderne, Paris

12 *Picture with white forms*
1913, oil on canvas, $47 \times 54\frac{1}{4}$ in (119×138 cm)
Guggenheim Museum, New York

13 *Small joys*
1913, oil on canvas, $43\frac{1}{4} \times 47\frac{1}{4}$ in (110×120 cm)
Guggenheim Museum, New York

14 *Black streaks*
1913, oil on canvas, $50\frac{1}{2} \times 50\frac{1}{2}$ in (128×128 cm)
Guggenheim Museum, New York

15 *Picture with white border*
1913, oil on canvas, $54\frac{3}{4} \times 78$ in (138.5×198 cm)
Guggenheim Museum, New York

16 *Improvisation XXXV*
1914, oil on canvas, $43\frac{1}{4} \times 47\frac{1}{4}$ in (110×120 cm)
Kunstmuseum, Basle

17 *Picture with red spot*
1914, oil on canvas, $51\frac{1}{4} \times 51\frac{1}{4}$ in (130×130 cm)
Musée d'Art Moderne, Paris

18 *Large study*
1914, oil on canvas, $39\frac{1}{2} \times 30\frac{3}{4}$ in (100×78 cm)
Boymans van Beuningen Museum, Rotterdam

19 *Black spot*
1921, oil on canvas, $54 \times 47\frac{1}{4}$ in (137×120 cm)
Kunsthaus, Zürich

20 *Red spot II*
1921, oil on canvas, $51\frac{1}{2} \times 71\frac{1}{4}$ in (131×181 cm)
Musée d'Art Moderne, Paris

21 *In the black circle*
1923, oil on canvas, $51\frac{1}{4} \times 51\frac{1}{4}$ in (130×130 cm)
Maeght Gallery, Paris

22 *Keeping quiet*
1924, oil on board, $21\frac{3}{4} \times 19\frac{1}{2}$ in (55.5×49.5 cm)
Boymans van Beuningen Museum, Rotterdam

23 *Form with horn*
1924, oil on board, $22\frac{3}{4} \times 19\frac{1}{4}$ in (58×49 cm)
Gallery of the 20th Century, Berlin

24 *Black triangle*
1925, oil on board, $31 \times 21\frac{1}{4}$ in (78.5×54 cm)
Boymans van Beuningen Museum, Rotterdam

25 *Yellow centre*
1926, oil on canvas, $17\frac{3}{4} \times 14\frac{1}{2}$ in (45×37 cm)
Boymans van Beuningen Museum, Rotterdam

26 *Lines with rays*
1927, oil on canvas, $38\frac{1}{2} \times 23\frac{3}{4}$ in (98×73 cm)
Guggenheim Museum, New York

27 *Square*
1927, oil on canvas, $28\frac{3}{4} \times 23\frac{3}{4}$ in (73×60 cm)
Maeght Gallery, Paris

28 *Spent red*
1927, oil on canvas, 26×30 in (66×76 cm)
Maeght Gallery, Paris

29 *Light in heavy*
1929, oil on canvas, $19\frac{3}{4} \times 19\frac{3}{4}$ in (50×50 cm)
Boymans van Beuningen Museum, Rotterdam

30 *One-two*
1929, oil on board, $13\frac{1}{2} \times 9\frac{1}{2}$ in (34.5×24.5 cm)
Boymans van Beuningen Museum, Rotterdam

31 *Scarcely*
1930, tempera with gesso, $13\frac{3}{4} \times 30$ in (35×76 cm)
Boymans van Beuningen Museum, Rotterdam

32 *White sharp*
1930, oil on canvas, $27\frac{1}{2} \times 19\frac{1}{2}$ in (70×49 cm)
Boymans van Beuningen Museum, Rotterdam

33 *Whimsical*
1930, oil on board, $15\frac{3}{4} \times 22\frac{3}{4}$ in (40×58 cm)
Boymans van Beuningen Museum, Rotterdam

34 *Succession of signs*
1931, indian ink and tempera on paper,
$16\frac{1}{4} \times 20$ in (41.5×50.5 cm)
Kunstmuseum, Basle

35 *Link*
1932, oil on canvas, $27\frac{1}{2} \times 23\frac{3}{4}$ in (70×60 cm)
Maeght Gallery, Paris

36 *Massive construction*
1932, gouache on board, 13×19 in (33×48.7 cm)
Kunstmuseum, Basle

37 *Development in brown*
1933, oil on canvas, $39\frac{1}{2} \times 47\frac{1}{4}$ in (100×120 cm)
Musée d'Art Moderne, Paris

38 *Close circles*
1933, tempera and oil on canvas, $39 \times 24\frac{3}{4}$ in (99×63 cm)
Maeght Gallery, Paris

39 *Dominant violet*
1934, oil and sand on canvas, $51\frac{1}{4} \times 63\frac{3}{4}$ in (130×162 cm)
Maeght Gallery, Paris

40 *Movement I*
1935, oil and tempera on canvas, $45\frac{3}{4} \times 35$ in (116×89 cm)
Musée d'Art Moderne, Paris

41 *Additional brown*
1935, oil on canvas, $32 \times 39\frac{1}{2}$ in (81×100 cm)
Boymans van Beuningen Museum, Rotterdam

42 *Red knot*
1936, oil on canvas, $35 \times 45\frac{3}{4}$ in (89×116 cm)
Maeght Gallery, Paris

43 *Centre with accompaniment*
1937, oil on canvas, $45 \times 57\frac{1}{2}$ in (114×146 cm)
Maeght Gallery, Paris

44 *The blue arch*
1938, watercolour, $10\frac{1}{2} \times 19\frac{1}{2}$ in (27×49.5 cm)
Emilio Jesi Collection, Milan

45 *The segment*
1939, gouache on board, $19\frac{1}{4} \times 12\frac{1}{4}$ in (49×31.5 cm)
Kunstmuseum, Basle

46–47 *The arrow*
1943, oil on board, $16\frac{1}{2} \times 22\frac{3}{4}$ in (42×58 cm)
Kunstmuseum, Basle

48 *Composition X*
1939, oil on canvas, $51\frac{1}{4} \times 76\frac{3}{4}$ in (130×195 cm)
Musée d'Art Moderne, Paris

49 *In the balance*
1942, oil and lacquer on canvas, $35 \times 45\frac{3}{4}$ in (89×116 cm)
Maeght Gallery, Paris

Biographical outline

Vassily Kandinsky was born in Moscow on 4 December 1866; in 1871 his family moved to Odessa and he began his studies and his first music lessons; his great grandmother was a Mongolian aristocrat and his maternal grandmother was German. His father was a man of considerable intelligence and showed a certain talent as a draughtsman. In 1886 at the age of twenty Kandinsky went to Moscow and took courses in law and economics at the Law faculty of the university. At this time he took part in a scientific expedition in the region of Vologda to collect information on the criminal laws and religious customs of the Surie tribes. During this journey he was much impressed by the carvings and pictures of Russian peasants. In the following years he visited the Hermitage and St Petersburg and admired the Rembrandts.

In 1892 after obtaining his law degree he made two journeys to Paris. In 1895 he went to the exhibition of French Impressionists in Moscow and saw Monet's pictures for the first time. In 1896 he was offered a university post at Dorpat but he refused and decided to go to Munich and devote himself to artistic studies. In 1896 he began publication of the periodical *Jugend*. From 1897 to 1899 Vassily was a pupil at Azbé's school where he met Jawlensky. In 1900 he joined Franz Struck's school at the Munich Academy where Klee and Marc also studied. Klee began his art studies in 1898 with a preliminary course at Knirr's school and finished at the Academy in 1901, a year after Marc began his studies. Marc's work at this time showed the first impressions of the ornamentation and linear emphasis of the Jugendstil in reaction to the strongly conservative teaching of the traditions of academic naturalism.

In 1901 Kandinsky began to work alone and founded the Phalanx group, taking part in various exhibitions with them. In 1902 while he was teaching at the school of the Phalanx, whose president he became, he met Gabrielle Münter. But a year later the school was closed and Kandinsky went to Venice, Odessa and Moscow. In 1904 the Phalanx broke up and Kandinsky travelled to Holland, Berlin, Paris and Kairouan in Tunisia with Gabrielle Münter. At this time he was working on tempera pictures and the first volume of woodcuts for *Poems without words*. From 1901 to 1902, approximately at the same time, Klee was travelling in Italy with the sculptor Hermann Haller and stayed at Milan, Rome, Naples and Florence, and from 1902 to 1906 in Berne where he produced etchings and paintings on glass. In 1904 he had stayed in Munich, studying primarily the works of Beardsley, Blacke and Goya at the Graphisches Kabinett, and in 1905 he was in Paris with Hans Bloesch and Louis Moilliet.

Then in 1906 he was in Berlin and in the same year in Munich where he remained till 1916; in 1911 he met Kandinsky. After being a pupil at the Munich Academy and after his Italian journey Klee had written: 'it was necessary to exploit and deepen all I had learned so far by working quietly'; Kandinsky had been more impulsive and had founded the Phalanx group, certainly an important event. The Phalanx artists had exhibited the French neo-Impressionists and the Belgian Symbolists in their own gallery.

The important factors in Kandinsky's cultural development as a young man, as his autobiography shows, were his impressions after seeing Monet's *Les meules* in 1895 in Moscow at the Impressionist exhibition, and listening to Wagner's *Lohengrin*. Both these influences are apparent in *The blue rider*, which Kandinsky painted in 1903 and which is now in the Bührle collection in Zürich. (The reasons have been explained in the text). He also had a draughtsman's passion for the colour and images of ancient styles, popular art and Russian Symbolism. In his autobiography (edited by Hilla von Rebay, published by Solomon Guggenheim, New York 1945 from the original text of the 1913 *Rückblicke*) Kandinsky remembers studying most closely the paintings of Balenov and the Russian Symbolist Borissov-Mussatov and learning to look for the first time in Vologda at a 'painting not only from the outside, and to enter into it, to move around in it and to mingle with its life'. This was in 1886. The decisive moment when his spirit matured came twenty years later in 1906 when he experienced the revolt of the Fauves and went to Paris; he stayed for a year and sensed the freedom that is possible in painting. Then came the experience of Expressionism which was important in Kandinsky's development primarily for the manner and the extent to which he came to terms with it; he went beyond its particular demands for a psychological content, for the distortion of the images in painting as a perceptive trauma of the image itself, for a content and a controversy that was an end in itself. On the contrary the graphic requirements of Expressionism did not interest him as an invitation to introversion or to simplify the figures which he had to justify with the apparent crudity of the technical means (which made these figures inhuman and ostentatiously superficial); but he did become interested in the search for a symbolical significance as a phenomenon in its mysterious course, as a potential image which by expressing itself rids itself of contingent facts through the dimension of memory in the origin and process of graphic rhythm. The passage from matter to space . . . between the dominion of the magical (matter) and the spirit (space). 'The Expressionists' colour theory', G. C. Argan wrote in the introductory essay in the catalogue for the Exhibition of the Graphic Arts of German Expressionism (March–April 1970, Palazzo Barberini, Rome), 'defines every value in relation to black, to darkness; this is

Poster for the 'Phalanx', 1901

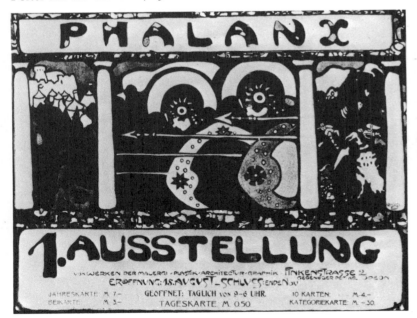

Kandinsky with Nina, Muche, Klee and Gropius in 1926

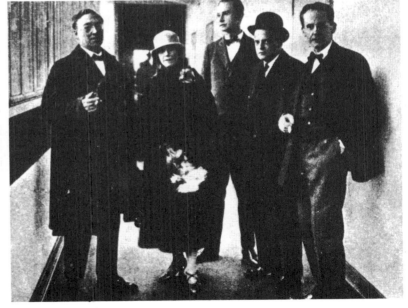

where it mainly differs from the Fauves' colour theory, which derives from Impressionism and defines every value in its relationship to white, to light.' The depth of psychic space as an inner fact lies in the 'third dimension' in Kandinsky's work; it arises from the colour and rhythm of movement, from forms in space, as an extremely sensitive demand from a categorical imperative and an *élan vital* of the creative conscience aspiring to express the 'eidetic presences' which are purer than phenomenological perception, in the more mysterious and fascinating reality which is the essence of the spirit in its infinite variety. We have mentioned this fundamental problem concerning Kandinsky's maturity, so that the facts of his life and work may be clarified by the reasons and the course of his inner need to discover the reality as a presence within the consciousness of man's spirit which is decisive in its demand for the abstraction of every fact of figurative nature.

Kandinsky proceeded from Fauve expressionism, where he differed in his view of nature from Marc, Macke and G. Münter, to a new perception of chromatic material which was as decisive as in the music of his time for the achievement of a pure abstraction of forms and colours; these have an ascending rhythm in their clear, intense shades, from sky blue to yellow ochre and to 'green which moving towards light or dark keeps its own original character of indifference and stillness' whilst 'blue exults and rises to heaven'. 'From colour to sound without a fracture'. 'Today is the time for a freedom which can be imagined at a point when a great era is commencing. And in the meantime this same freedom represents one of the major deprivations of freedom, since all the freedoms which it gives access to arise from a single source: the categorical imperative of inner necessity. The artist is not life's favoured darling: he has no right to live without a task. And he must know that each of his acts, his feelings, his thoughts, constitutes the thin, imponderable but solid materials from which his works are created: that therefore he is not free in life, but only in art.'

In 1907 Worringer's *Abstraktion und Einfühlung* was published; it stated that all art is fundamentally subjective; this strongly influenced Kandinsky's theoretical development. In 1908 Kandinsky returned to Munich and became friendly with Werefkin and Jawlensky.

In 1909 he went to Murnau and painted a series of Murnau landscapes. In the same year the New Association of Munich Artists, with Kandinsky as president, was founded, and he began his series of *Improvisations*. In 1910 he painted the first abstract water-colour and the first three *Compositions*, met Franz Marc and wrote *Concerning the Spiritual in Art*. Then he went to Moscow, St. Petersburg and Odessa. The year 1911 was one of the most important years in his life: he met Klee, Arp and Macke and with Marc he founded the Blaue Reiter. From 18 December 1911 to 1 January 1912 the first

Blaue Reiter exhibition was held in Munich; *Concerning the Spiritual in Art,* the *Blaue Reiter* almanac and *Yellow Sound* (Kandinsky's poems) were also published, there was also a Blaue Reiter Exhibition at the Sturm in Berlin, at the first German autumn salon. In 1914 when war broke out, Kandinsky went to Rorschach; he then spent three months at Goldach on Lake Constance, and then he stayed at Zürich, Odessa and Moscow. Klee, Macke and Moilliet went to Kairouan, as Kandinsky had done. Kandinsky himself was in Stockholm from December 1915 to March 1916; at the end of 1916 he separated from Gabrielle Münter and married Nina de Andreewsky in the following year. Kandinsky's pictures were exhibited in 1917 in the Zürich Dada Gallery, together with pictures by Arp, de Chirico, Max Ernst, Feininger, Klee, Kokoschka, Marc, Modigliani and Picasso.

In 1918 Kandinsky became a professor in the Academy of Fine arts in Moscow and worked in the art section of the People's Commissariat for Public Education. His book *Looking Back (Rückblicke)* was published in Russian. In 1919 he was appointed as director of the Museum of Artistic Culture and he set up twenty-two provincial museums. He met Pevsner and Gabo, the founder of Constructivism. In 1920 he became a professor at Moscow University. He founded the Academy of Artistic Sciences and became its vice-president. But at the end of December, since full artistic freedom was not being recognized he left the USSR and went to Berlin. In 1922 he was appointed professor at the Bauhaus, and taught there till 1932, first in Weimar, then in Dessau, where the school had moved. In 1924 he founded the 'Four Blues' movement with Klee, Feininger and Jawlensky. In June 1925 he moved to Dessau. In 1926 he published *Point and Line to Plane* in which he attempted to analyse the perception of the abstract elements of painting. In 1928 he and his wife obtained German citizenship. He produced Mussorgsky's *Pictures from an exhibition* at the Dessau Theatre. In 1929 Kandinsky's first Paris show was held at the Zack Gallery; he then went to Belgium, where he met Ensor, and the French Riviera. In 1930 the Galerie de France organized another Kandinsky exhibition in Paris; in 1931 he arranged the décor of the great Exhibition of German Architecture in Berlin. In the same year he went to Egypt, Syria, Turkey and Greece. In March 1933 the Bauhaus was closed by the Nazi government. In 1934 he met Miró, Delaunay and Mondrian, and became friends with Pevsner, Arp and Magnelli. In the summer he went to Normandy. In 1936 he went to Italy and visited Forte dei Marmi, Pisa and Florence. In 1937 he visited Klee in Switzerland. Fifty-seven of his works were confiscated by the Nazi Government as degenerate art. In 1939 he obtained French citizenship. In 1940 he stayed two months in the Pyrenees. On 13th December 1944 he died at Neuilly-sur-Seine.

Kandinsky with Klee and Nina at Dessau in 1932

Vassily and Nina Kandinsky in 1933

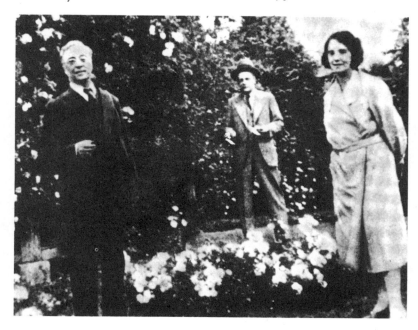

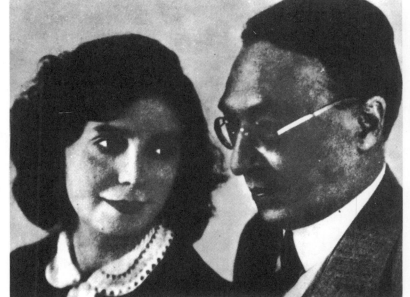

Bibliography

BOOKS AND ARTICLES BY VASSILY KANDINSKY

'Rückblicke', Der Sturm, Berlin, 1901–13; expanded Russian edition, Tekst Khudozhinika, Moscow, 1918; English edition by HILLA VON REBAY, Kandinsky, New York, 1945 and In Memory of Vassily Kandinsky, New York, 1945; French edition, Regard sur le Passé, Paris, 1946; 2nd German edition, Baden-Baden, 1955; Über des Geistige in der Kunst. Insbesondere in der Malerei, Piper, Munich, 1912; English edition, The Art of Spiritual Harmony, London, 1914; Japanese edition, The Art of Spiritual Harmony, Tokyo, 1924; Italian edition, Della Spiritualità nell 'Arte, particolamente nella pittura, Religio, Rome, 1940; American editions, On the Spiritual in Art, New York, 1946, Concerning the Spiritual in Art and Painting in Particular, New York, 1947; French edition, Le Spirituel dans l'Art et dans la Peinture en Particulier, Paris, 1951; Spanish edition, De lo Espiritual en el Arte y la pintura en particular, Buenos Aires, 1956; Der Blaue Reiter, Piper, Munich, 1912, 2nd edition 1914; Italian edition, Il Cavaliere Azzuro, De Donato, Bari, 1967 (with essays by Buriluc, Macke, Schönberg, Allard, Hartmann, Busse, Sabancev, Kublin), Klänge, Munich, 1913; Punkt und Linie zur Fläche; Beitrag zur Analyse der malerischen Elemente, Langen, Munich, 1926, 2nd edition, H. BAYER, Bauhausbücher, 9, 1928, 3rd edition edited by Max Bill with the same title, Bümplitz, Berne, 1955; French edition 'Analyse des Elements Premiers de la Peinture', Cahiers de Belgique, 4th May 1928; English edition in the translation by HILLA VON REBAY, Point and Line to Plane, Museum of Non-Objective Painting of New York, New York, 1947; Italian edition in the translation by MELISANDO CALASSO, Punto, Linea superficie, Adelphi, Milan, 1968; Essay über Kunst und Künstler, essays from 1912 to 1943 collected by Max Bill, Stuttgart, 1955.

ILLUSTRATED EDITIONS AND VARIOUS TEXTS, INTRODUCTIONS, ESSAYS AND ARTICLES BY KANDINSKY

Poesies sans Paroles, Stroganoff, Moscow, 1904; (14 woodcut plates in black and white); woodcuts in Tendences Nouvelles, 1906–07 nos. 26, 27,28 and 29; Woodcuts, Tendences Nouvelles edition, Paris, 1909; Der Sturm, Verlag Der Sturm, Berlin, 1910; Content and Form, introduction in Russian to the catalogue of the International Art Exhibition in Salon 2, Odessa, 1910–11; Der Blaue Reiter, edition with colour plates, Piper, Munich, 1912, 2nd edition, 1914 (the artist had written the introduction to the catalogue to the exhibition Der Blaue Reiter for the Tannhäuser Gallery, Munich); Über das Geistige in der Kunst, Munich, 1912, with ten black and white plates; 'Kandinsky-Kollektiv-Ausstellung, 1910–12', introduction by Kandinsky to catalogues of the exhibitions held in Berlin 1912 and the Gallery Goltz, Munich, 1912–13; Klänge, prose poems published by Piper, Munich, 1912; with 56 black and white and coloured plates 'Über Kunstverstehen', Der Sturm III no. 129, October 1912; Letters to A. J. Eddy in ARTHUR J. EDDY, Cubist and Post Impressionist, Chicago, 1913; Neue Europäische Graphik, Vierte Mappe; Italienische und Russische Kunstler, Stadtliches Bauhaus, Weimar, 1921; 'Ein Neue Naturalismus' in Das Kunstblatt VI September 1912; Kandinsky, introduction to the Kandinsky exhibition at the Gummeson's Kunsthandel, Stockholm, 1922; Klein Welten Zwölf Blatt Original graphik, Propläen, Berlin, 1922; (introduction to etchings and coloured and black and white lithographs by Kandinsky); Meister Mappe des Staatlichen Bauhauses, Staatliches Bauhaus, Weimar, 1923; 'Abstrakte Kunst', Der Cicerone VII, 1925; 'Der Wert des theoretischen Unterriches', Bauhaus no. 4, December 1926; 'Über die abstrakte Bühnensynthese', Bauhaus no. 3, 1927;' "Und" einiges über synthetische Kunst', I dieci 1, Amsterdam, 1927; 'Kunstpädagogik' Bauhaus no. 2, 3, 1928; 'Unterricht Kandinsky', Bauhaus nos. 2, 3, 1928; 'Über die Abstrakte Malerei', introduction to the Kandinsky-Jubiläumsausstellung exhibition at the Frankfurter Kunstverein, Frankfurt-am Main, 1928; 'Der Blaue Reiter, Rückblick' Das Kunstblatt no. 14, February 1930; 'Klee', Bauhaus no. 3, December 1931; 'Reflexions sur l'art abstrait', Cahiers d'Art 6, nos. 7, 8, 1931; 'L'art d'aujourd'hui est plus vivant que jamais', Cahiers d'Art 10, nos. 1, 4, 1935; 'Line and fish', Axis no. 2, London, 1935; 'To Retninger, Det Abstrakte Rene Malerei Skaber', Konkretion, September 1935; 'Abstrakte Malerei', Kronick von Hedendaagsche Kunst en Kultuur, Amsterdam, April 1936; 'Theseis antithesis synthesis', introduction to the catalogue of the exhibition at the Kunstmuseum, Lucerne, 1935; 'Omaggio a Baumeister', Il Milione, Milan, May–June 1935; 'Vassily Kandinsky', introduction to the exhibition by Kandinsky at the Kunsthalle, Berne, 1937; 'Zugang zur Kunst', Liniens Sammenslutning, Efter-Expressionisme, Copenhagen, 1937; Transition no. 27, April–May 1938 (Kandinsky designed the cover); 'Abstrakt over Konkret', introduction to the catalogue of the Tentoonstelling Abstracte Kunst at the Stedelijk Museum, Amsterdam, April 1938; 'Blick und Blitz', Transition no. 27, April–May 1938, with poems and texts; 'L'art concret', XXe Siècle, no. 1, March 1938; 'Mes gravures sur bois', XXe Siècle, no. 3, July–September 1938; 'Abstract and concrete art' in the catalogue of the exhibition at the Guggenheim Jeune Gallery, London, 1939; 'Lettere a Rebay', written in Paris from 1934 to 1938 and published by HILLA REBAY in Vassily Kandinsky Memorial, Museum of Non-Objective Painting, New York, 1945; 'L'arte concreta', in the catalogue of the Exhibition of Abstract and Concrete Art, Palazzo Reale, Milan, 1947; 'Poetry and statements of the artist' Michel Seuphor, L'Art Abstrait, Paris 1949; Statements of the artist reported in the catalogue of the exhibition Der Blaue Reiter 1908–14 at the Kunsthalle, Basle, Spring 1950.

GENERAL WORKS, ESSAYS, MONOGRAPHS, CATALOGUES, ARTICLES RELATING TO INTERESTING ASPECTS OF THE THOUGHT AND WORK OF VASSILY KANDINSKY

HENRI BERGSON, Matière et memoire, Alcan, Paris, 1896; ID L'energie spirituelle, Alcan, Paris, 1919; ID. L'évolution créatrice, Plon, Paris, 1926; EDMUND HUSSERL, 'Ideen zu einer reinen Phänomenologie und phänomenologischen Philosophie I', Jahrbuch f. Philo. u. phänomenologie und phänomenologischen Philosophie, 1913 (Italian trans, G. HALLINEY, Einaudi, Turin, 1950), II, unpublished thesis published by W. BIEMEL, Hague, 1952; EDMUND HUSSERL, Die Krisis der europäischen Wissenschaften und die transzendentale Phänomenologie, I and II Philosophia, Belgrade, 1936; Italian trans. E. FILIPPINI, Il Saggiatore, Milan, 1961; MARTIN HEIDEGGER 'Sein und Zeit, Jahrbuch f. Philo. u. phänomen. Forschung; Italian trans. P. CHIODI, Bocca, Milan, 1953; ERNEST CASSIRER Philosophie der symbolischen Formen, III, Phänomenologie der Erkenntnis, Bruno Cassirer, Berlin, 1929; H. B. BLAVATSKY, The key to theosophy, Theosophical Society, London, 1898; E. EVANS, 'Artists and art life in Munich', The Cosmopolitan, no. 6, October 1892; ID, 'Kunsterclub Phalanx' Die Kunst füre Alle no. 16, 1901; W. MICHEL, 'Münchner Graphik; Holzschnitt und Lithographie', Deutsche Kunst und Dekoration, April–September 1905; GEROME-MAESSE, 'L'audition colorée', Les Tendences Nouvelles, no. 27, 1907; GEORGE J. WOLF, Kunst und Einfühlung, Munich, 1911; H. WALDEN, 'Wochenschrift für Kultur und die Künste,' Der Sturm, Berlin, 1910–15; RUDOLPH LEONHARD, Kandinsky, Dürer-Bund, Munich, 1912; FRANZ MARO, Die neue Malerei, Pan, Berlin, 1912; W. STEENHOF, 'de Expressionist: Kandinsky', De Amsterdammer, December 1912; FRANZ MARC, 'Kandinsky Der Sturm, February 1913'; HERMANN BAHR, Expressionismus, Munich, 1916; THEODOR DAUBLER, Der Neue Standpunkt, Dresden-Hellerau, 1916; HERWART WALDEN, 'Einblick in Kunst: Expressionismus, Futurismus, Kubismus', Der Sturm, Berlin, 1917; HELGE LUNDHOLM, 'Kandinsky (Analyse des theories de ce peintre)' Flammen Sueder, no. 2, 1917; KATHERINE DREIER Western Art and the New Era, New York, 1923; WILL GROHMANN, 'Vassily Kandinsky' Der Cicerone nos. 16, 19, September 1924; ID. Vassily Kandinsky (monograph), Leipzig, 1924, Paris, 1930; CARL EINSTEIN, Die Kunst des 20 Jahrhunderts, Berlin, 1926, 1928, 1931; THIEME-BECKER, Allgemeines Lexikon der Bildenden Künstler, Leipzig, 1926; KAZIMIR MALEVIC, Die gegenstandslose Welt, Munich, 1927; Bauhausbücher, Munich 1925–29, Bauhaus Zeitschrift für Gestaltung, Dessau, 1926–29–31; WILL GROHMANN, Die Sammlung Ida Bienert, Potsdam, 1933; ID. and ANATOLE JAKOVSKIJ, Kandinsky (monograph), Tenerife, 1935; CHENEY SHELDON, Expressionism in Art, New York, 1943; WOLFGANG PAULSENI, Expressionismus und Aktivismus, Strasbourg, 1934; PAUL DICKERMANN, Die Entwicklung der Harmonik bei A. Scriabin, Leipzig and Berne 1935; RENE HUYGHE, Histoire de l'Art contemporain (La peinture), Paris, 1935; PIERRE COURTHION 'Kandinsky et la peinture abstraite', Le Centaure, nos. 6, 10, Brussels, 1930; ERNST KALLAI, 'Vision und Formgesetz', Blätter der Galerie Ferdinand Möller, no. 8, September 1930; ANDRE BRETON and PAUL ELUARD, 'Enquete' Minotaure no. 3, December 1933; CHRISTIAN ZERVOS, 'Notes sur Kandinsky, Cahiers d'Art 9, nos. 5–8, 1934; ID. 'Mathematiques et art abstrait', Cahiers d'Art nos. 1, 2, 1936; ALFRED BARR Jr., Cubism and abstract art, Museum of Modern Art, New York, 1936; CHRISTIAN ZERVOS, 'Histoire de l'Art Contemporain', Cahiers d'Art, Paris, 1938; WILL GROHMANN, L'art contemporain en Allemagne, Cahiers d'Art Nos. 1, 2, 1938; SAMUEL RICHARD and THOMAS R. HINTON, Expressionism in German life, literature and theatre, Cambridge, 1939; WILHELM VALENTINER, 'Expressionism and abstract painting', Art Quarterly 4, no. 3, 1941; PEGGY GUGGENHEIM, Art of this Century, New York, 1942; CORRADO MALTESE, 'Kandinsky e il concetto dell'arte astratta', Arti Figurative, anno III, 1943; MAX BILL, 'Von der abstrakten zur konkreten Malerei im XX Jahrhundert', Pro Arte et Libris, Geneva, 1943; SIDNEY JANIS, Abstract and Surrealist Art in America, New York, 1944; ANDRE BRETON 'Genese et perspective artistique du Surrealisme', Labyrinte, no. 5, 1945; JULIA and LYONEL FEININGER, 'Vassily Kandinsky' Magazine of Art, 38, May 1945; EDWARD JEWELL, Mondrian, Kandinsky Memorial, New York Times, 25 March 1945; EJILE BILLE, Picasso, Surrealisme, Abstrakt Kunst, Copenhagen, 1945; KENNETH LINDSAY, Om 'op og ned' paa Abstrakt Billede in Kunst, Copenhagen, 1945; GUISEPPE MARCHIORI, 'Mondo di Kandinsiu', Ulisse 4, no. 12, June 1945; MAUDE RILEY, 'In memoriam Kandinsky' Art Digest, 19 January 1945; CHRISTIAN ZERVOS, 'Vassily Kandinsky' Cahiers d'Art 20–21, 1944–46; LUKOMSKIJ, History of Modern Russian Painting, London 1945; PAUL JAMATI, 'Kandinsky' L'Arche no. 15, 1946; NINA KANDINSKY, 'Some notes on the development of Kandinsky's painting', Kunsthaus, Zürich 1946; ID. Le développement de la peinture non-objective concrète (manuscript reproduced in the library of the Museum of Modern Art, New York), 1946; HILLA REBAY, 'pioneer in non-objective painting', Carnegie Magazine, 20 May 1946; WILLI BAUMEISTER, Das Unbekannte in der Kunst, Stuttgart, 1947; GILLO DORFLES, 'Importanza storica dell 'Espressionismo tedesco', Arti Belle no. 2, 1947; LASZLO MOHOLY-NAGY, Vision in Motion, Chicago, 1947; HUGO DEBRUNNER 'Wir entdecken Kandinsky', Zusammenarbeit mit Laien, Künstlern, Psychologen, Zürich, 1947; HERBERT READ, Art Now, London, 1948; MADELEINE ROUSSEAU. 'De Cézanne et Seurat à l'art présent', Musée Vivant, no. 34, 1948; MAX BILL, 'Die mathematische Kenkweise in der Kunst unserer Zeit', Werk no. 3, 1949; MICHEL SEUPHOR, L'Art Abstrait, Paris 1949; MAX BILL, Vassily Kandinsky (monograph), Basle, 1949, Boston and Paris 1951 (with articles by Jean Arp, Charles Estienne, Carola Giedon-Welker, Will Grohmann, Ludwig Grote, Nina Kandinsky, Alberto Magnelli); CHARLES ESTIENNE, 'Situation de Kandinsky' Art d'aujourd'hui, October 1949; JEAN ARP, Onze Peintres vus par Arp, Zürich 1949; CAROLA GIEDON-WELKER, 'Kandinsky Malerei als Ausdruck eines geistigen Universalismus', Werk 37, no. 4, April 1950; KENNETH LINDSAY, An Examination of the Fundamental Theories of Vassily Kandinsky, University of Wisconsin, 1951; 'Great harmony show of 1913: Kandinsky painter number one', Life no. 28, New York, January 1950; BERTO LARDERA, 'Biennale 1950; Notes sur la synthése des arts plastiques', Les Arts Plastiques 4, 1950; DENYS

SUTTON, 'L'Expressionisme à la XXV Biennale de Venise', *Les Arts Plastiques*, 4, 1950; CHARLES ESTIENNE, 'Vassily Kandinsky' in the catalogue of the XXV Biennale of Venice, 1950; ID. 'Deux éclairages: Kandinsky et Miró', *XXe Siècle no. 1*, 1951; WILL GROHMANN, 'La grande retrospettive di Kandinsky alla XXV Biennale', *La Biennale, Venice no. 3*, January 1951; G. C. ARGAN, *Walter Gropius et la Bauhaus*, Einaudi, Turin, 1951; MAURICE RAYNAL, *History of Modern Painting* (3 volumes), Skira, Geneva, 1950; GUISEPPE MARCHIORI, *Pitura Moderna in Europa*, Pozza, Venice, 1950; GERMAIN BAZIN, *History of Modern Painting*, New York, Paris, London, 1951; UMBERTO APOLLONIO, '*Die Brücke*' e la Cultura dell'Expressionismo, Alfieri, Venice, 1952; 'Kandinsky' *The Institute of Contemporary Art Bulletin*, April, 1952; EMIL UTITZ, *Uber Kunst und Künstler Hoag*, Drugulin, Leipzig, 1959; HERBERT BAYER, *Bauhaus 1919–1928*, Museum of Modern Art, Boston, 1952 (ed. originally New York 1938); CHARLES ESTIENNE, 'Kandinsky ou la liberté de l'esprit', *Les Arts Plastiques 4*, 1952, WILL GROHMANN, *Bildende Kunst und Architektur*, Suhrkamp, Berlin, 1953; HERBERT READ, *The Philosophy of Modern Art*, Horizon, New York, 1953; HARRY HOLTZMANN, 'Liberating Kandinsky' *Art News 51*, New York, 1952; KENNETH LINDSAY, 'Kandinsky method and contemporary criticism', *Magazine of Art*, 45, December 1952; ALINE B. LOUCHEIM, 'Time adds lustre to Kandinsky', *New York Times*, April 1952; GEORGE WALDEMAR, 'Les illuminations de Vassily Kandinsky', *Art et Industrie*, no. 26, Paris, 1953; NINA KANDINSKY, W. GROHMANN, A. RANNIT, 'Ciurlonis e Kandinsky', *La Biennale*, no. 26, Venice, 1953; KENNETH LINDSAY, 'Mr Pepper's defence of non-objective art', *Journal of Aesthetics and Art Criticism 12*, December 1953; ID. 'Genesis and meaning of the cover design for the first Blaue Reiter exhibition catalogue' *Art Bulletin 35*, March 1953; 'Kandinsky, oeuvre gravée', catalogue of the Bergruen Exhibition, Paris, 1954; WERNER HAFTMANN, *Malerei im 20 Jahrhundert*, volume 2, Prestel, Munich, 1954–55; LUIGI ROGNONI, *Espressionismo e dodecafonia*, Turin, 1954; PAUL SCHMIDT, *Geschichte der Modernen Malerei*, Stuttgart, 1954; PETER SELTZ, *German Expressionist Painting*, Chicago University, Chicago, 1954; WILL GROHMANN, 'Le Cavalier Bleu', *L'oeil*, no. 9, Paris, September 1955; ALEXANDER LIBERMAN, 'Vassily Kandinsky' *Vogue*, 126, New York, (November) 1955; KLAUS BRISCHU, *Vassily Kandinsky* (monograph), Bonn University, 1955; WILL GROHMANN, *Kandinsky: Farben und Klänge Erste Folge* (monograph), Baden Baden 1955; MICHAEL JAFFÈ, 'Een Schilderij ult Kandinsky's beginperiode', *Boymans Museum Bulletin 7*, no. 11, 1955; WERNER HOFMANN, 'Studien zur Kunsttheorie des 20 Jahrhunderts' *Zeitschrift für Kunstgeschichte*, Vienna, January, 1956; WILL GROHMANN, 'Blaue Reiter', *The Selective Eye*, 1957; G. C. ARGAN, 'L'Arte astratta, ancora dell'arte astratta', *Studi e note*, Turin, 1958; NELLO PONENTE, 'Kandinsky', *Saggi e Profili*, Rome 1958; PALMA BUCARELLI, 'Presenza di Kandinsky', introduction to the catalogue of the exhibition at the Galleria Nazionale d'Arte Moderna (May–June 1958), Editalia, Rome, 1958; ID 'Kandinsky' *Accademia XXXVI no. 5*, May 1958; HILTON KRAMER, 'Toward an art of mysticism, the life and work of Kandinsky', *Arts no. 33*, New York, December 1958; RENATO BARILLI, 'La XXIX Biennale', *Il Verri no. 3*, 1958; MARISA VOLPI, 'Mostre alla Galleria d'Arte Moderna, Pollock e Kandinsky', *Bollettine d'Arte, XLIII*, 1958; J. P. HODIN, 'V. Kandinsky: Life and work' by Will Grohmann in 'Guardia Europea', *La Biennale, nos. 36–37*, July–December 1959; HERBERT READ, *Kandinsky* (monograph), London, 1959; WILL GROHMANN, *Art in Revolt, Germany, 1905–1925*, London, 1959; E. H. GOMBRICH, *Art and Illusion*, Washington, 1959; P. SELTZ and M. CONSTANTINE, *Art Nouveau*, Museum of Modern Art, New York, 1950; ANDRÉ CHASTEL, 'Kandinsky ou le voeu intérieur 1921–27' *Derrière le Miroir*, 1960; F. MENNA, 'L'ipotesi metafisica dell'arte astratta', *Commentari no. 3*, 1961; R. ARNHEIM, *Arte e percezione visiva*, Il Saggiatore, 1962; LAWRENCE ALLOWAY, 'London Letter', *Art International nos. 5–6*, June–August 1961; PETER FINGSTEN, 'Spirituality, mysticism and non objective art', *Art Journal*, New York 1961; WILL GROHMANN, 'Kandinsky et Klee retrouvent l'Orient', *XXe Siècle, XXIII*, December 1961; ROBERTO SPIRA, 'Kandinsky weg zur abstrakten Kunst', in *Weltkunst XXXI, no. 10*, 1961; PIERRE VOLBOUDT, 'Kandinsky entre les deux réalités, *XXe Siècle, XXIV no. 19*, June 1962; CARLO RAGGHIANTI, *Mondrian e l'arte del XX secolo*, 1962; P. RIEDL, *Kandinsky Kleine Welten*, Stuttgart 1962, D. CHEVALIER, 'Vassili Kandinsky ou la conquête de la paix intérieure' *Aujourd'hui 7*, May 1963; KRAMER HILTON, 'The Guggenheim retrospective raises questions concerning Kandinsky's contribution as artist and as theoretician', *Artforum, Vol. I* 1963; P. VOLBOUDT, *Kandinsky 1896–1921 et 1922–44* (monograph), 2 volumes, Paris, 1963; DONALD JUDD, 'Kandinsky in his citadel' *Arts no. 62*, May 1963; JULES LANGSNER, 'Kandinsky at Pasadena', *Arts, no. 62*, May 1963; JACK KROLL, 'Kandinsky, last of the heresiarches', *Art News, Vol. LXII no. 10*, 1963; L. MOHOLY NAGY, 'Retrospective at the Basel Kunsthalle', *Burlington Magazine*, 105, 1963; FRITZ NENGASS, 'Kandinsky, Retrospective', *Weltkunst XXXIII 4*, New York, 1963; R. SOUPAULT, 'Quand j'étais l'élève de Kandinsky', *Jardin des Arts*, June 1963; PAUL OVERY, 'The later painting of Vassily Kandinsky' *Apollo Vol. XXVIII, 18*, 1963; H. R. RÖTEHEL, Catalogue of the Blaue Reiter exhibition, in Munich, 1963; DANIEL ROBBINS, 'Vassily Kandinsky, Abstraction and image', *The Art Journal XXII, no. 3*, 1963; MARISA VOLPI, 'Kandinsky' *La Biennale nos. 50–51*, December 1963; EBERHARD ROTHERS, 'Vassily Kandinsky und die Gestalt des Blauen Reiters', *Jahrbuch der Berliner Museen, Vol. V. no. 2*, 1963; ERNST HARMS, 'My association with Kandinsky', *American Artist, Vol. XXVII, no. 6*, 1963; JEAN CASSOU, 'Kandinsky en France', Catalogue of the exhibition in New York, Paris, Basle, 1963; PAUL OVERY, 'Colour and sound', *Apollo no. 27*, May 1964; CAMILLA GRAY, *Pionieri dell'arte in Russia, 1863–1922*, Milan, 1964; LEOPOLDO EHLINGER, 'Kandinsky', *L'Oeil*, June 1964; CARLO BELLOLI, *Il contributo russo alle avanguardi plastiche*, Milan, 1964; SERGEJ EISENSTEIN, *Forma e tecnica del film e lizioni di regia*, Einaudi, Turin, 1964; MARISA VOLPI, 'Pittura, Sculpture, Grafica', catalogue of the exhibition of Expressionism, Florence, 1964; G. C. ARGAN, *Salvezza e caduta nell'arte moderna*, Il Saggiatore, Milan, 1964; ID *Progetto e destino*, Il Saggiatore, Milan, 1965; LADISLAO MITTNER, *L'Espressionismo*, Laterza, Bari 1965; *Rassegna Sovietica* of January–March 1965, essays by Argan, Arkin, Birk, Luna-Carskij, Malevic, Puni,

Punin; *XXe Siècle*, December 1966, *Centenaire de Kandinsky* with unpublished essays of Vassily Kandinsky and essays on his work by Arp, Albers, G. C. Argan, P. Bucarelli, P. Bonler, Dorival, W. Grohmann, N. Kandinsky, G. Dupin, P. Dorazio, K. G. Lindsay, A. Kojeve, I. Leppien, G. Muche, Nishida, Miró, Magnelli, M. Messer, R. Kirkpatrick, C. Giedon Welcker, Stuckenschmidt, San Lazzaro, H. Read, I. Stravinsky, G. Schneider, Soupoult-Niemeyer. (Remembering this special number of *XXe Siècle* devoted to Kandinsky's work, we also draw attention to the special number of *Sélection no. 14* for his graphic work) *Kandinsky*, Antwerp, 1933 with articles by W. GROHMANN, F. MORLION, G. MARLIER, CH. ZERVOS, W. BAUMEISTER, M. SEUPHOR, A. SARTORIS, E. BUYS, D. RIVERA, A. DE RIDDER, E. L. CARY, G. E. SCHEIER and the 'Catalogue de l'Oeuvre gravé et dessin' compiled with Kandinsky's assistance, including his graphic works from 1902 to 1932 and drawings from 1910–32; TROELS ANDERSEN, 'Some Unpublished Letters by Kandinsky', in *Arts Periodical of fine arts, Vol. II*, 1966; C. JURGEN, 'Show at Städtische Galerie', *Kunstwerk*, Munich, 1966; JOHN RUSSELL, 'A Manifold Moses: Some notes on Schoenberg and Kandinsky', *Apollo Vol. LXXXIV no. 57*, 1966; MARISA VOLPI, 'Tre momenti della cultura di Kandinsky', *Marcatre, nos. 23, 24, 25*, 1966; ARTURO BOVI, 'Tempo dell'alienazione e crisi dell'uomo' (Testimonianze di Proust, Kafka, Klee e Musil), *Civiltà delle Macchine, XIV no. 4*, July–August 1966; MAURIZIO CALVESI, *Dinamismo e simultaneità nella poetica futurista*, Milan, 1967; ID, *Il futurismo russo in L'arte Moderna*, Fabbri. Milan, 1967; MARISA VOLPI, *Kandinsky e il Blaue Reiter*, Fabbri, Milano, 1967; FRANK WHITFORD, 'Some notes on Kandinsky's development towards non-figurative art', *Studio International, Vol. 173, no. 885*, 1967; RENATO BARILLI, 'Internazionalità del Simbolismo', *Arte Moderna Vol. II, fasc. 17*, 1967; GILLO DORFLES, *Il divenire delle arti*, Einaudi, Turin, 1967; A. ARNDT, E. ROTERS, H. RICHTER, ROIESEN VON H. E. BUCHOLZ, D. HELMS, H. WEITEMEIER, I. LEERING, *Avantgarde Osteuropa 1910–1930*, Akademie der Kunst, Berlin, October–November 1967; K. ROBERTS, 'Kandinsky and his friends', *Burlington Magazine*, January, 1966; C. R. WASHTON, 'Kandinsky's fraction of Mystery', *Arts Magazine, Vol. 41, no. 3*, December, 1967; MARISA VOLPI, *Kandinsky dall'Art Nouveau alla Psicologia della forma* (monograph), Lerici, Rome, 1968; M. MERLEAU PONTY, *Le visible e l'invisible* (from the unfinished ms edited by Claude Lefort), Italian edition, Bompiani, Milan, 1969 (Merleau Ponty's ideas are explained in his important book *Fenomenologia della percezione*, Il Saggiatore, Milan, 1965); G. C. ARGAN, 'Grafica dell'Expressionismo tedesco', introduction to the catalogue of the exhibition at the Ente Premi, Rome, Palazzo Barberini, March–April, 1970; PALMA BUCARELLI, WERNER SCHMANELBACH, 'Klee' two introductory essays to the catalogue by the exhibition of Paul Klee's works at the Galleria Nazionale d'Arte Moderna, April–May 1970, De Luca, Rome, 1970; ITALO MUSSA, 'Grafica dell'Espressionismo tedesco' *Due Punti*, July 1970.